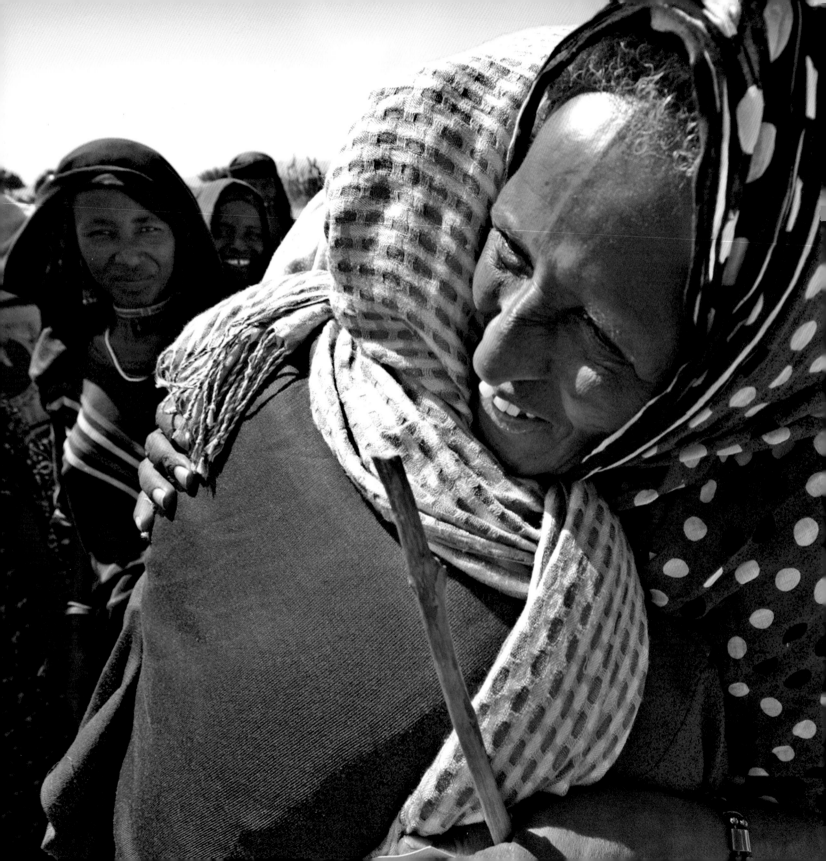

WOMEN EMPOWERED

INSPIRING CHANGE IN THE EMERGING WORLD

PHIL BORGES

FOREWORD BY

MADELEINE K. ALBRIGHT

RIZZOLI
NEW YORK

CONTENTS

MADELEINE K. ALBRIGHT

THIS IS A BOOK ABOUT HOPE, BASED ON REALITY.

IT RESTS ON THE PREMISE that the ancient enemies of human progress—poverty, ignorance, and disease—can be defeated, or at least forced to retreat, through the empowerment of women and girls. As evidence, this book presents not a wealth of statistics or a detailed explanation of a complex economic model. Instead, it offers the stories of some remarkable women who are working every day to transform their communities and build a brighter future for their families.

THROUGH THE STUNNING PHOTOGRAPHY and straightforward commentary of Phil Borges, readers come to know how women such as Fahima in Afghanistan, Abay in Ethiopia, Hasina in Bangladesh, and Violeta in Ecuador are improving and enriching their own lives, and those of the people around them.

THE EXPLOITS OF THESE WOMEN are not detailed in the newspapers or featured on headline television news. Their contributions occur off-camera, in remote villages and crowded neighborhoods. But taken together, their efforts and those of millions like them have immense power. Experience has shown that when women have the freedom to make their own economic and social choices, the chains of poverty can be broken; families are strengthened; income is used for more productive purposes; the spread of sexually transmitted disease slows; and socially constructive values are more likely to be handed down to the young.

CYNICS HAVE LONG SUGGESTED that development assistance, so easily dismissed as "foreign aid," is money down a rat hole. The truth is that programs that are poorly designed, transitory, insensitive to local conditions, or overly politicized are doomed to fail. But programs that enable or encourage women to participate more fully in the economic and political life of their societies have a strong record of success. I have seen this myself in traveling throughout the emerging world, where experts from humanitarian organizations such as CARE have identified strategies that consistently lead to positive results.

THROUGH DECADES OF OBSERVATION and study, these experts have learned that reproductive health services can save the lives of millions of women and children, and lead to better long-term health for entire families. They have learned that ensuring access to basic education for girls provides the firmest possible foundation for social development. They have learned that training women to employ low-cost measures to protect against unsafe water or disease-carrying insects can dramatically improve public health. They have learned that village savings and loan groups can enable women to start small businesses, create jobs, and begin to accumulate capital. They have learned that working for change does not mean simply imposing one's views on another, and that harmful practices, such as female circumcision, are best countered not by blunt condemnation but by reasoned explanation, in which the religious and cultural justification for the customs are analyzed, the pain caused by the process is fully understood, and a new consensus is reached.

FINALLY, THESE EXPERTS have learned that the subjection and sidelining of women in the twenty-first century is not only wrong, but also economically unsustainable. No country can make progress if half its population is held back, left out, or pushed aside. Men and women, girls and boys, must go forward together.

WOMEN IN POOR COUNTRIES inevitably play a central social role. Because of the obstacles many face, they also have a strong interest in ensuring that knowledge is shared. This is why poverty-fighting projects that focus on women are so constructive; each becomes a platform for further gains. Women are eager to explain what they have learned to their children and neighbors. Archana Kundu, a mother and member of a CARE-supported women's self-help group in rural India, put it this way: "For us to have a better life, the people around us have to have a better life. You just can't have a good life when people around you are unhappy. We have a moral responsibility to support the women around us. I enjoy doing it. Now I know so much, I want to share it."

AS THE U.S. SECRETARY OF STATE, I was privileged to represent my country in nations around the world. I had many meetings with high officials in fancy offices, but those are not the meetings that I remember most. The people I will not forget are those I encountered in refugee camps, rehabilitation centers for amputees, safe havens for trafficked women, and clinics for mothers with HIV/AIDS. These are the places where the human spirit undergoes its toughest tests and where people live on less money each day than most of us spend on a can of soda or a cup of coffee. As the representative of the world's richest and most powerful nation, I was often asked for an assurance that these women and their children would not be forgotten and that their experiences would serve as a catalyst for change.

BACK IN WASHINGTON D.C., I was asked a different question. Why should we care about fighting poverty in the emerging world? I was told that the task was hopeless, that we could not afford to undertake it, and that we had too many other problems about which to worry. I replied that we had learned over and over again that the gravest dangers to world security have deep roots. Desperation, when allowed to fester, begets violence, ethnic strife, terrorism, international crime, and the forced displacement of people. Development, on the other hand, provides the basis for broader markets, new democracies, stability, and peace.

I BELIEVE DEEPLY that if the developed world did more to help the deserving, especially women, we would see children everywhere become citizens and contributors; we would see young people put down roots and establish a niche in the global marketplace; and we would see whole countries benefit from the energy and skills of all their people. The good news, in which democratic societies have always believed, is that human security, prosperity, and freedom are dynamic, not finite; if we plant the seeds and till the soil, they will grow. Here an organization like CARE is essential, for its very purpose is to cultivate, nourish, and sustain our faith in each other and in ourselves.

UNDERLYING ALL THIS is the simple view that every individual—male or female—counts. This is the philosophy of democracy at its best, and it has been the driving force for six decades behind the work of CARE.

THIS VIEW IS NOT BASED ON ANY ILLUSIONS; humanitarian workers, in particular, have seen far too much of tragedy and death to indulge in sentimentalism. But we live in a world that has been immeasurably enriched by the survivors, by those who have lifted themselves out of poverty and have overcome hardships to blaze new trails to success.

THESE PAGES INTRODUCE A SMALL SAMPLING of such pioneers and pathfinders. We learn their names and see their faces, and witness the work of their hands and minds. We are encouraged and inspired, and filled with hope. We are also challenged to consider what we can do—each in our own way—to create a world more free, prosperous, and humane than it has ever been.

This century will be

remembered not for conflicts

or technical inventions, but as a time

in which human society dared to think of

the welfare of the whole human race

as a practical objective.

—ARNOLD TOYNBEE

PHIL BORGES

WHEN I FIRST ENTER A REMOTE VILLAGE OR TRIBAL AREA, I'm usually greeted by the children. My photographic equipment gives me the perfect opportunity to interact without having to use words. A small crowd of kids usually gathers as I take photos and hand out Polaroids and digital prints. It's my little magic show that allows me to quickly integrate into communities rarely visited by foreigners.

TYPICALLY, THE YOUNG BOYS ARE THE BOLD ONES, wanting to help or hamming it up for the camera. The girls, with few exceptions, are more hesitant and remain at the edge of the group. Over the years, I wondered how this difference between preadolescent boys and girls could be prevalent in so many different cultures. I thought this was just an inherent quality of "girl-ness" and "boy-ness."

THEN I BEGAN TO REALIZE THAT THESE ROLES AREN'T INHERENT AT ALL; they are taught and they are learned as part of a pattern of discrimination against women and girls. Seeing it manifested by such varied communities and in the behavior of such young children opened my eyes to how deep and universal gender inequality is. While the women's movement in the West has made much progress, I continue to be shocked by how women's rights are compromised in the developing world. It occurs in every arena: education, division of household labor, political representation, access to credit, available health care . . . the list goes on.

IN MOST OF THE RURAL COMMUNITIES I visit, girls are responsible for collecting firewood and water—tasks that can take several hours a day. They also help their mothers with the washing, cooking, farming, and childcare. One reason given for sending boys to school and not girls is that their domestic work is critical to the family's survival and their time cannot be spared for education.

SO WHILE MOST WOMEN SERVE as the primary caretakers in the family, they have no chance to learn even basic skills, like reading or math, that would allow them to carry out their roles more effectively. It is common for women to have little or no direct say in community decisions and to have marginal access to land or other assets. Afar women of Ethiopia illustrate the point: They do the majority of the work that keeps the family alive—they even build the houses—yet they are not allowed to attend the meetings where elder males decide the rules that govern their community. I was dumbfounded and dismayed when I heard more than one of these strong, capable women say, "I'm just a woman. What do I know?"

OVER THE YEARS, I have wrestled with the issue of "cultural imperialism." Who is to decide which cultural practices deserve to be preserved, and which should be eliminated? Who are we to tell an African community to stop a circumcision ceremony that has served as a longstanding cultural rite of passage, even when it is women who are being circumcised? And with respect to gender inequality, who is to decide which roles men and women are allowed to play in their culture?

IN 2004, I BEGAN DOCUMENTING the work of the humanitarian organization CARE. Empowering women and girls is the cornerstone of their program to eliminate global poverty. After spending a year and a half visiting dozens of CARE projects and meeting hundreds of participants and staff around the world, I too came to believe that the most efficient way to alleviate poverty and reduce population pressures in the developing world is to empower women and girls through education, economic opportunity, and open discussions about rights.

I HAD THE GOOD FORTUNE of meeting the women whose stories are presented in this book. I witnessed what's possible when a woman no longer struggles each day to survive in the face of hunger and disease. I have seen the spark ignite when a woman realizes that she can create lasting change—for herself, her children, and her community. When women are free to make the most of their skills and ideas, they create a rising tide that lifts all boats.

HERE ARE JUST A FEW of the extraordinary women I have met that have broken through a cycle of repression or cultural tradition that limited their well-being and the well-being of their communities—women heroes, remote and unknown, on the vanguard of a global shift toward gender equality.

WOMEN PRODUCE HALF OF THE WORLD'S FOOD,

OF THE 867 MILLION illiterate adults in the world, two-thirds are women.

ON AVERAGE, women represent a mere ten percent
of all elected legislators worldwide.

EIGHTY PERCENT of the world's refugees and displaced
people are women and girls.

AN INCREASE OF ONE YEAR in the average education of a nation's women
corresponds to a five to ten percent decrease in that country's child mortality rates.

BUT OWN JUST ONE PERCENT OF ITS FARMLAND.

A UNITED NATIONS' STUDY showed that while women spend
ninety percent of their income on their family, men put only thirty to
forty percent of their earnings toward theirs.

WORLDWIDE, at least one in three women has been beaten, coerced into sex,
or abused in some way, most often by someone she knows.

BETWEEN 100 AND 140 MILLION girls and women have
been subject to female genital mutilation.

ABOUT ONE IN SEVEN GIRLS in the developing world gets
married before her fifteenth birthday.

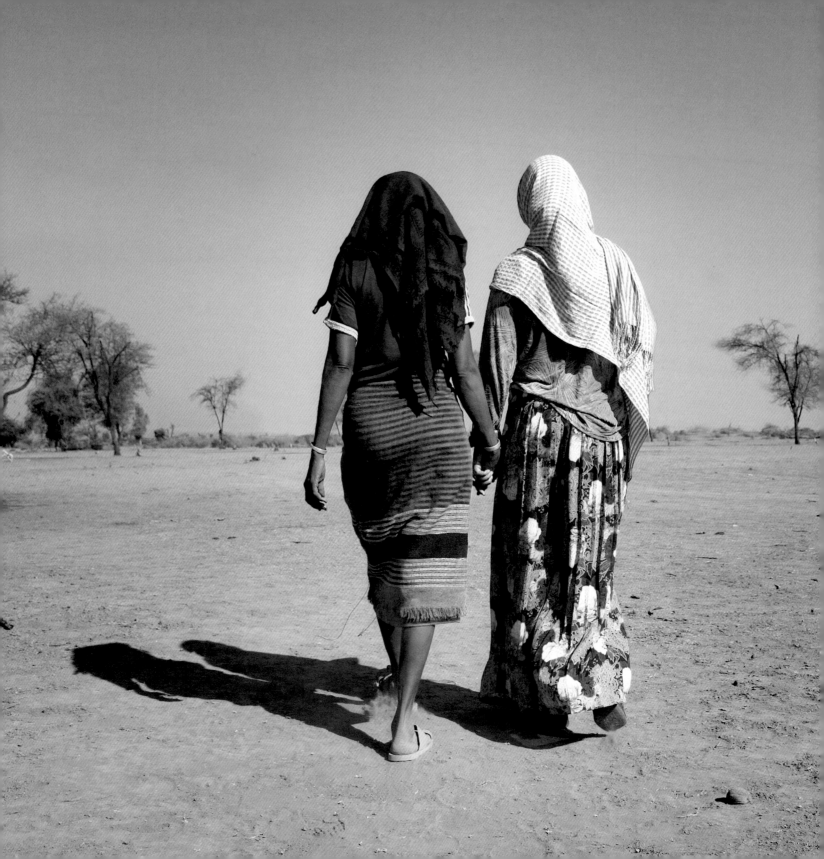

THE WOMEN

Portraits of Empowerment

FAHIMA, 38

KABUL, AFGHANISTAN

Fahima, a teacher since 1985, was one of thousands of professional women
who lost their jobs when the Taliban came to power in 1996. In defiance of the Taliban and
at great risk to herself, Fahima opened a clandestine school for young girls. At one point, 130
girls were coming to her home each week to study math, science, and the local language, Pushto.
When the girls were asked why they were going to Fahima's house, they said she
was their aunt. Although harassed by the religious police and threatened with
beatings and worse, Fahima continued operating her school
for girls until the fall of the Taliban in 2001.

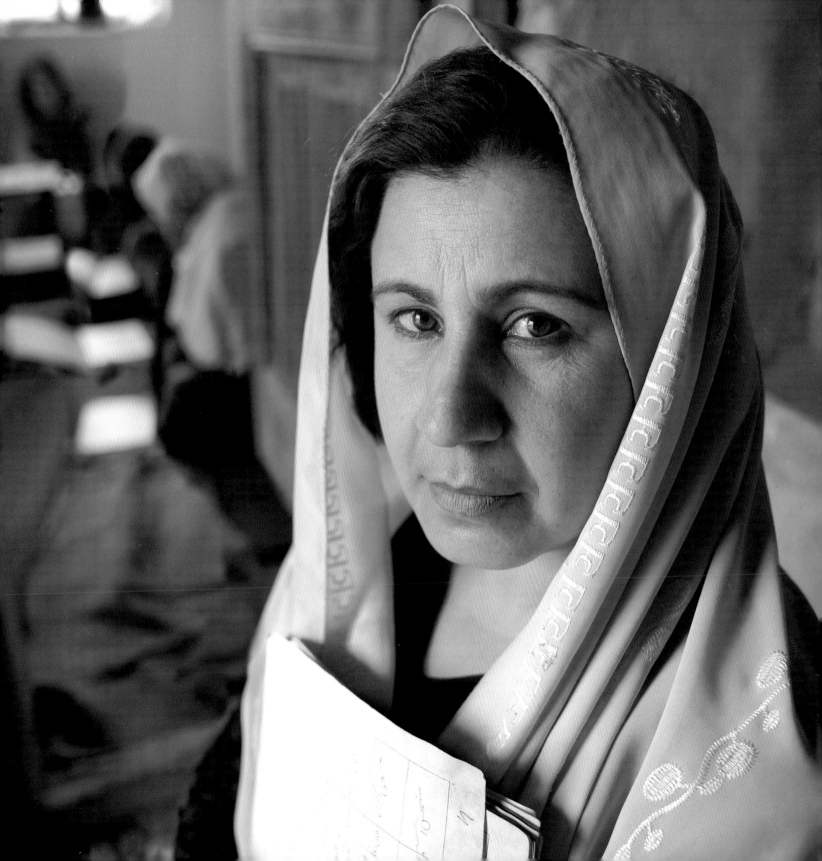

When the Taliban came to power, the social and civil consequences were severe. Women were banned from employment and education and forbidden to go out in public without a close male relative. Prior to the Taliban rule, women made up seventy percent of the teachers, fifty percent of the civil servants, and forty percent of the doctors.

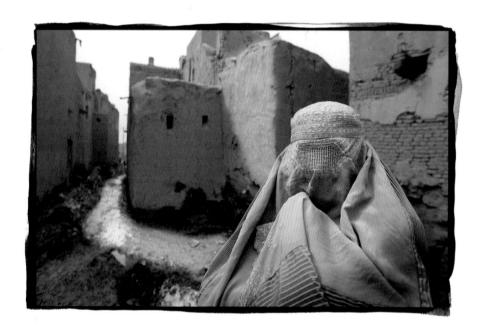

SHOKIRA, 21

When Shokira was 8 years old, the Taliban came to power and her education came to an end.
Without access to clandestine classes like Fahima's, she received no schooling. She recently enrolled in
a literacy program for young women to make up for the education that she was denied. Forced to wear the burqa
in public during the Taliban reign, she now chooses to wear it when she does not have time to fix her hair.

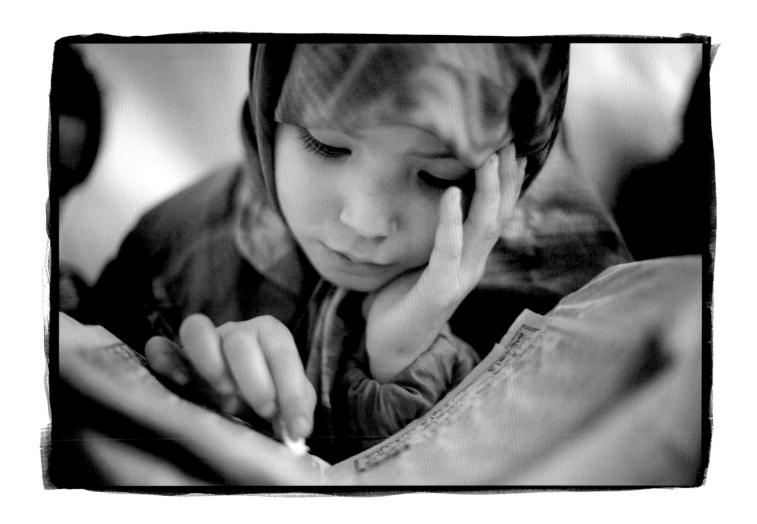

NAFISA, 7

Nafisa was thrilled when she learned she was chosen to attend Salman-e-Fars, a new school
recently opened for young girls in Kabul. Girls now make up thirty-four percent of the student
population in Afghanistan—a dramatic increase since the Taliban rule, when it was essentially zero.

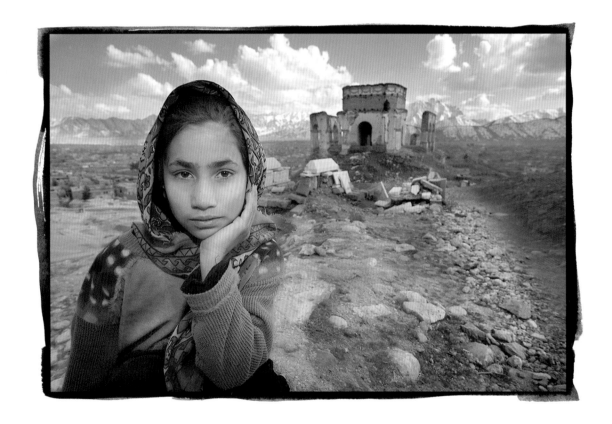

HUMARIA, 11

Humaria sells eggs as a street vendor to help her family survive. As with
many families in Afghanistan, years of war have left them very poor. Only half of all Afghan children
ages 7 to 13 attend school. When the luxury of education is an option, boys are typically chosen over girls.

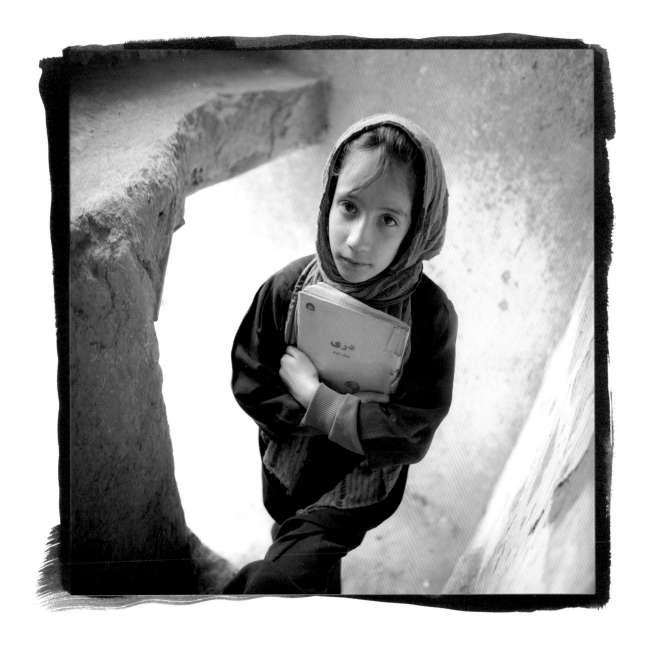

YELDA, 12

Unlike the girls in Fahima's secret school, Yelda had to stay at home and help her family make carpets until the
Taliban fell. Now she would like to become a teacher and specialize in English. She has enrolled in the Out-of-School
Girls Project, a program supported by CARE and designed to help girls ages 9 to 14 rejoin the mainstream education system.

ABAY, 28

AWASH FONTALE, ETHIOPIA

Abay was born into a culture in which girls are
circumcised before age 12. When it came time for her
circumcision ceremony, Abay said, "No." Her mother insisted,
aruging that an uncircumcised woman would be ostracized
and could never marry. When her mother's demands became
unbearable, she ran away to live with a sympathetic godfather.
Eight years later, Abay returned to her village and began work as
a station agent for CARE, supervising the opening of a primary
school and a health clinic and the construction of a well. After
five years, she finally convinced one of the women to let her film a
circumcision ceremony. She showed the film to the male leaders.
They had never seen a female circumcision and were
horrified. Two weeks later, the male leaders called a special
meeting and voted fifteen to two to end female
circumcision in their village.

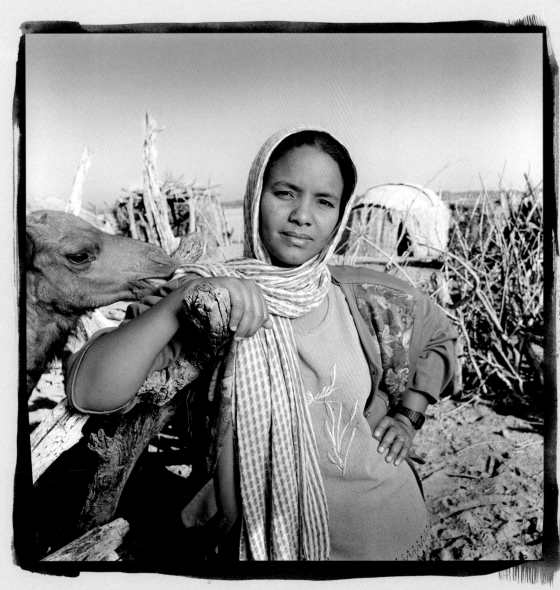

Although it is the women's labor that holds the family and community together among the 1.3 million nomadic Afar, women are not allowed to attend the community meetings that govern their lives. Afar women frequently utter a crippling belief: "I'm just a woman. What do I know?"

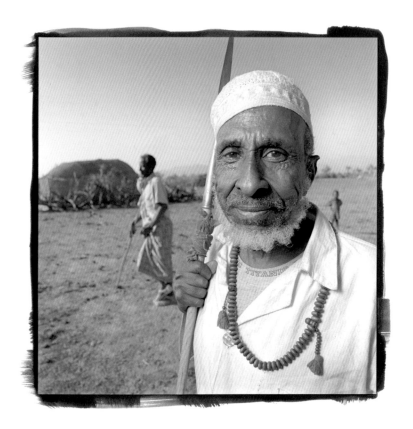

HAJI WALDO, 70

Haji is one of the leaders in Awash Fontale that voted to end female circumcision after viewing Abay's film of the procedure. He said, "Now that I have seen this film, I could never let my granddaughters go through this ceremony."

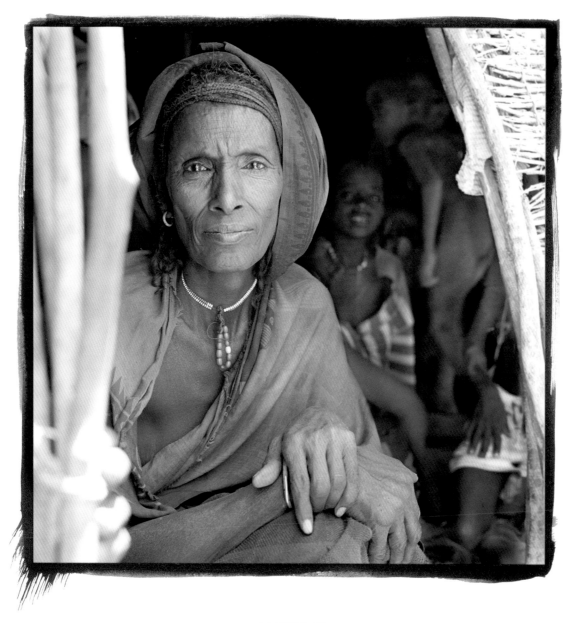

ASGELI, 52

As a leader of the circumcision ceremony, Asgeli had performed hundreds of female circumcisions.
Now, like others in the village, she is supportive of the change in custom that Abay has advocated. She said,
"We did the circumcisions because that is what had always been done. We were in the dark house and did not know."

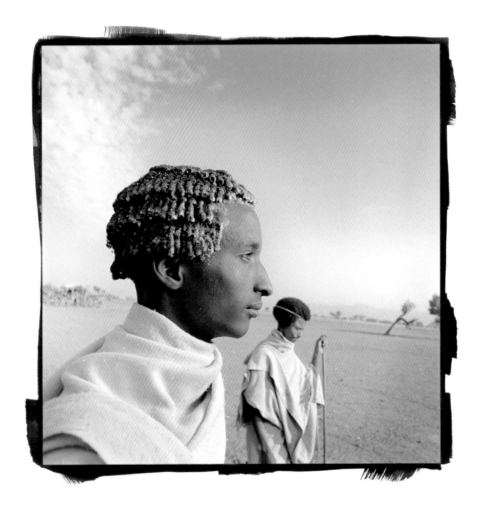

SENIM, 20

Traditionally in the Afar culture it would be unthinkable for a young
man to marry an uncircumcised girl. With Abay's help, this attitude is changing. When I asked Senim if
he would consider marrying an uncircumcised woman he said, "It would be strange, but now I think I could."

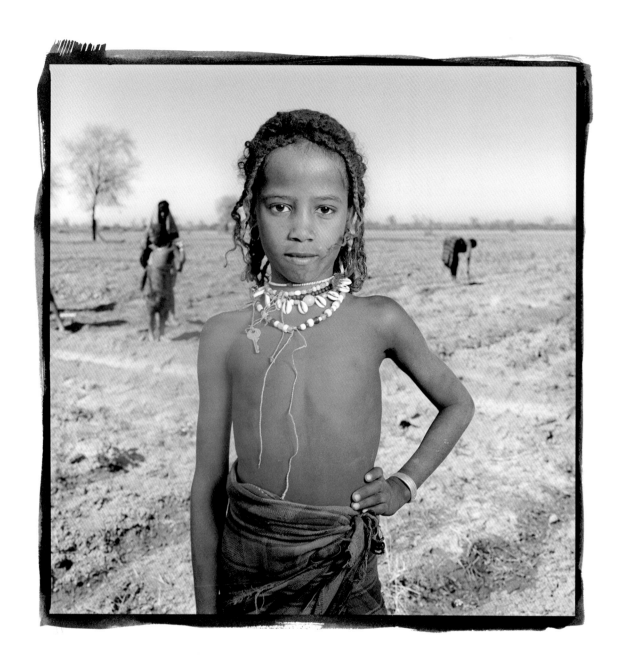

HOWA, 8

Howa's mother was one of the first women in Awash Fontale to be
convinced that female circumcision was a "bad practice." Thanks to Abay's
efforts, Howa will be the first girl in her entire family history not to be circumcised.

RENCHIN, 59

DHARAMSALA, INDIA

In 1991, a group of sixty-six Tibetan nuns appeared on the streets of Dharamsala, India. Fleeing Chinese persecution, the refugees had nowhere to live, nothing to eat, and no support network. Renchin, a Tibetan refugee herself, helped the nuns find housing and establish a nunnery. Her efforts grew into the Tibetan Nuns Project, an organization that provides exiled nuns with shelter, health care, and, notably, advanced educational opportunities.

Traditionally, Tibetan nuns have been taught how to pray, but not the meaning of their prayers. With no direct lineage to the teachings of Buddha, the nuns lacked the ancestry necessary for ordainment. Only monks could become ordained teachers and, through their teaching, support themselves. By giving the nuns the education necessary to become teachers, Renchin has opened the door to their economic independence.

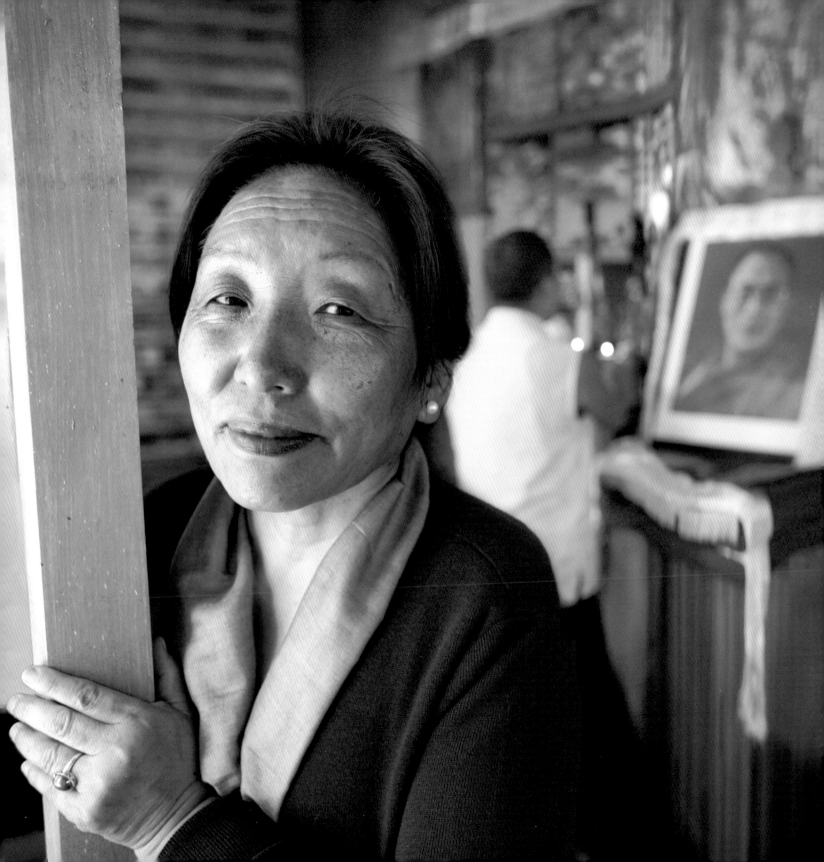

When the Tibetan monks sought refuge in India, they had the support of the monasteries in Dharamsala.
By contrast, the nuns had no place to go. Today, the Tibetan Nuns Project supports
over five hundred exiled nuns, with projects in four nunneries.

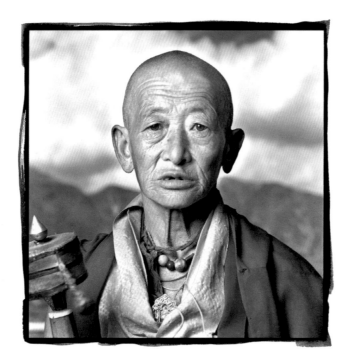

TAMDIN, 69

Tamdin was imprisoned and tortured for taking part in a demonstration in Lhasa in 1987.
She escaped across the Himalayas, walking for thirty-five days to seek refuge and an audience with her
spiritual leader, the Dalai Lama. When I took this photograph just three days after her arrival in India in
1994, she was wearing the same beat-up tennis shoes that had taken her across the mountains.

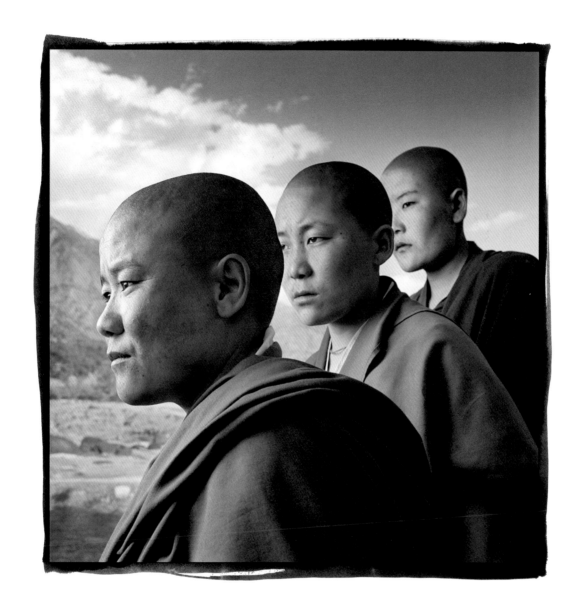

KALSANG, 25; NGAWANG, 22; DECHEN, 21

These nuns were imprisoned for two years for protesting China's occupation of Tibet.
Arriving in Dharamsala, they were taken to the Dolmaling Nunnery, established by Renchin,
to recover. At the nunnery, they hope to receive an education before resuming their resistance efforts in Tibet.

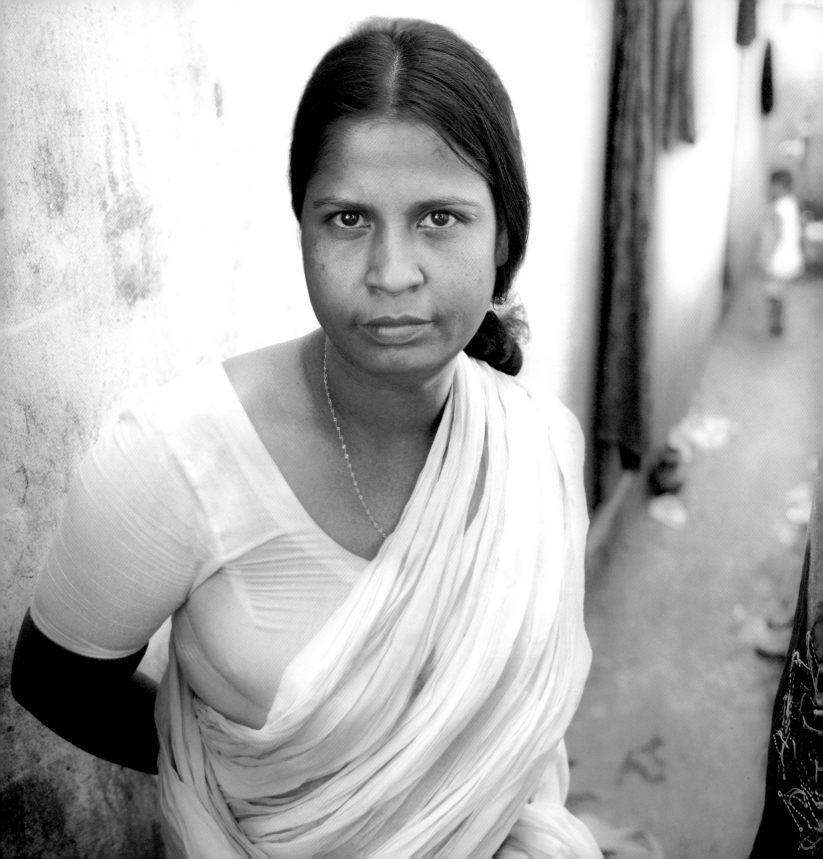

AKHI, 32

TANGAIL, BANGLADESH

At age 13, before she had even begun menstruating, Akhi was sold into a
brothel by her aunt. After working for several years, she became deeply depressed
and attempted suicide. Her failed attempt brought about an epiphany: Her life
could be used to improve the lot of her fellow sex workers.

Akhi accomplished the near-impossible task of gaining support from religious,
political, and social groups to create an organization to advocate for sex workers' rights.
Despite being arrested three times, she prevailed and, in 1998, formed the "Nani Mukti Sangha"
organization. Since the group commenced, condom use in the brothel has increased from near
zero to eighty-six percent, and the number of 12- to 13-year-olds recruited into the brothels
has decreased. Today, she continues to fight tenaciously for sex workers' rights, and is
said to have such a forceful personality that even the police are afraid of her.

Although prostitution is legal in this Muslim nation, sex workers have lacked basic rights. They've been denied the opportunity to open bank accounts, go to health clinics, have a proper burial, or enroll their children in school. Due to the strong social stigma against sex workers, most remain in brothels through the end of their lives.

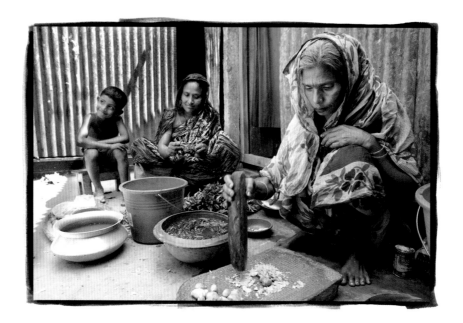

Since women over age 30 are considered sexually undesirable and stigma prevents
them from leaving the brothel, their only choice for financial support is domestic work within
the brothel. Akhi's efforts are well on the way to changing this pitiful situation.

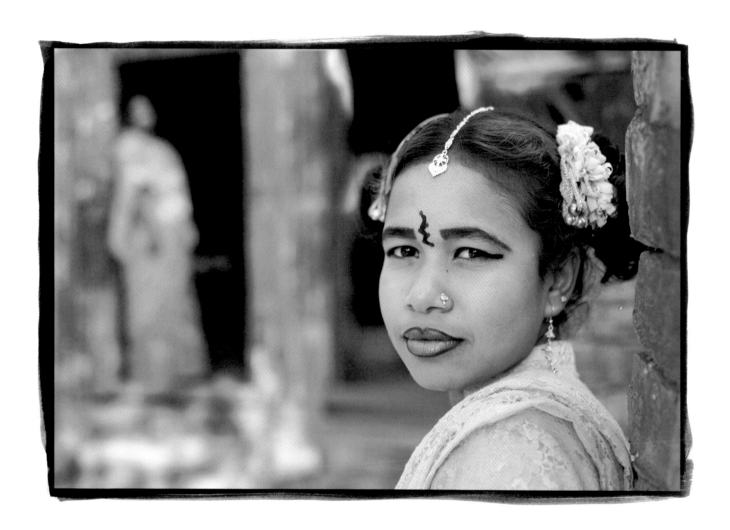

CHANDI, 17

Like Akhi, Chandi entered the sex trade because of a relative. Four years after her mother died,
Chandi was tricked into joining a brothel by a stepmother who promised she would have a job cleaning
houses. It is estimated that ninety-eight percent of women who join brothels in Bangladesh do so against their will.

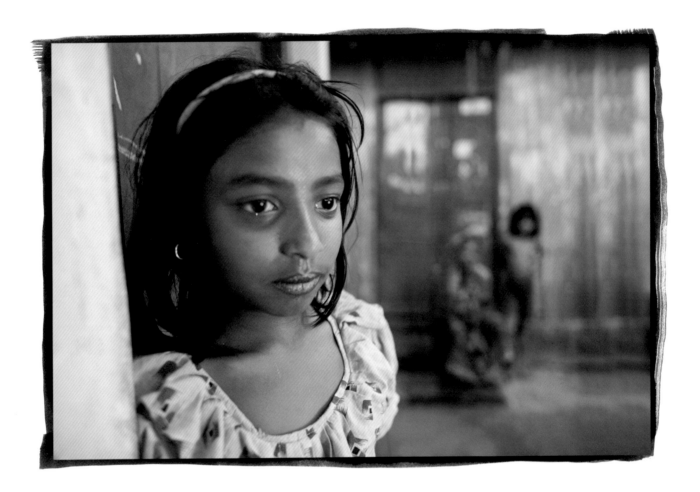

JASMINE, 9

Jasmine was born in a brothel to a sex worker. The children of sex workers are so stigmatized in
the community that they are not allowed to go to school, and Jasmine will therefore most likely have to begin
sex work in two or three years. Akhi's efforts to end such stigmatization will create a better future for these young girls.

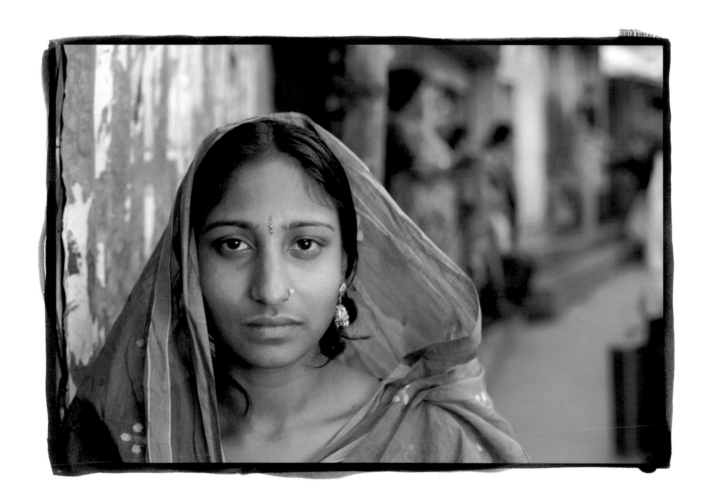

AKLIMA. 23

At age 17, Aklima was sold into a brothel for 170 dollars. She has since paid
off her madam, but remains stuck in the brothel, noting: "By the time we are free from
our bondage, the community does not accept us, and it is impossible to leave."

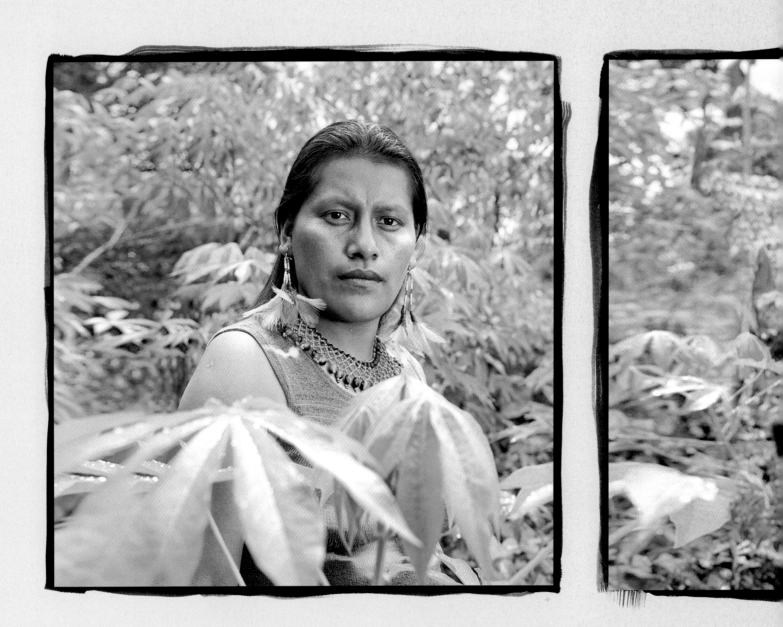

VIOLETA, 29

GUADALUPE, ECUADOR

Violeta grew up in an indigenous and male-dominated
culture. Although a vast majority of Shuar girls drop out
of school to get married in their mid-teens, Violeta both
completed high school—while pregnant with her
third child—and earned a teaching degree. Today,
she has become the first woman leader in her
traditionally "machista" society.

Using skills obtained from CARE workshops,
Violeta is teaching women and girls lessons on gender equity
and cooperation. Slowly, the social fabric is changing. Where
men once sat around waiting for food after work, many now
return home and help out with domestic chores. Women may
pursue moneymaking activities and are not confined to their
traditional roles of cooking, cleaning, and child rearing.

Violeta said that previously it was typical to see a Shuar man walking down the street with his wife trailing twenty feet behind, loaded with goods, but things are slowly changing thanks to the financial empowerment of women.

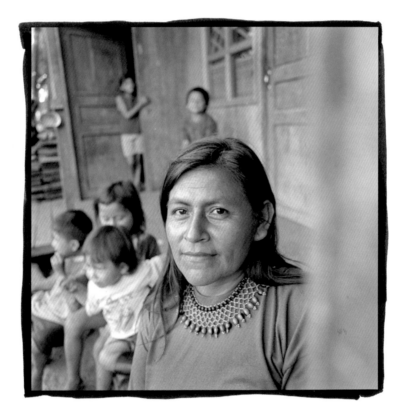

HILDA, 55

Hilda, Violeta's mother, dropped out of school at age 14 to get
married. Seeing her daughter's accomplishments and the respect she has received
in the community have inspired her to go back to school to get a high-school degree.

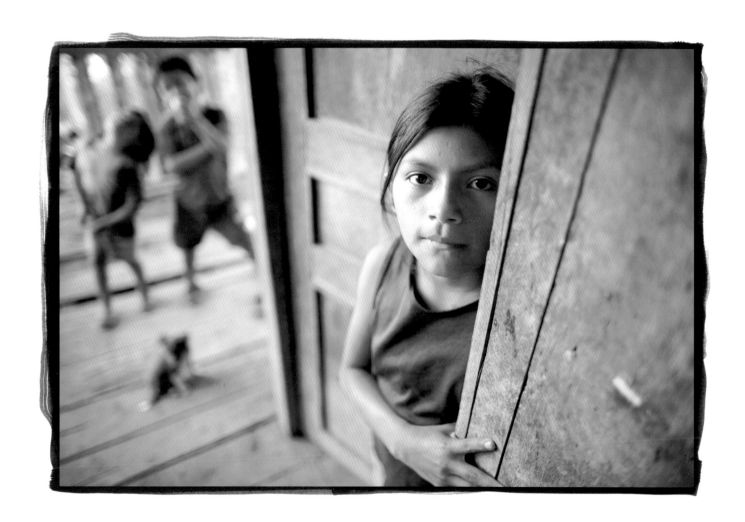

WENDY, 9

Just a few years ago, girls like Violeta's oldest daughter Wendy would have
been given to an older man to marry as early as her thirteenth birthday. Wendy, who sees her
mother as a leader in the community, is now in third grade and aims to become a teacher.

CHRISTY TURLINGTON BURNS

EVERY TIME I TRAVEL THE WORLD, I'm deeply humbled and transformed by the countless women I encounter who are affecting change in their communities. It reminds me that, with a little support and a lot of conviction, the power to change our personal worlds is always within reach. And for any woman who has struggled with her own feminine identity, there's nothing more reassuring or rewarding than recognizing yourself in the life of another woman, despite the cultural differences and disparity in individual challenges that may exist. This connectedness of all women gives strength to the idea of community, and that strength can help women realize their potential—as individuals, leaders, and providers, and as one of the greatest resources on earth. In my own life, whenever I'm searching to find that enigmatic balance among my roles as mother, wife, and businesswoman, I reflect on the courage of women like the ones you find on these pages. These women connect with the innate power within each of us that we must learn to own—a power that enables us to move mountains.

Christy Turlington Burns is a CARE Ambassador, entrepreneur, and author.

We deny the right of any portion of the species to decide

for another portion what is and what is not their 'proper sphere.'

The proper sphere for all human beings is the largest and

highest which they are able to attain to.

—HARRIET TAYLOR MILL

GILO, 50

YABELO, ETHIOPIA

Gilo is one of 500,000 nomadic Borana pastoralists in Southern Ethiopia.
The girls in Gilo's village spent four hours a day fetching water from a distant spring before
CARE helped the community build a cistern nearby. The cistern made education a possibility for
scores of children. However, eight-hour school days integrate poorly with the Borana's lifestyle.
Recognizing the need for a more flexible schooling structure, Gilo successfully lobbied to create
a "Non-Formal Education Center." The school employs two teachers in a mobile, stick-frame
building. Its flexible schedule enables children both to work for their families and to receive
a basic education. Gilo proudly accompanies her 7-year-old daughter Galmo
to and from school every day. Galmo is the first person
in Gilo's family ever to attend school.

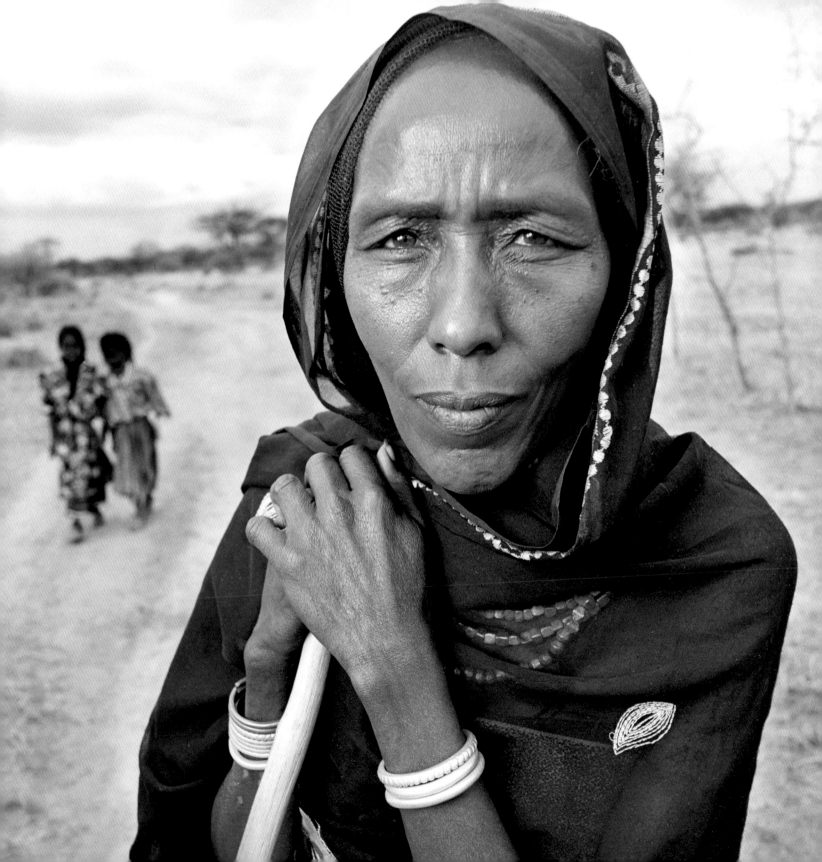

Pastoralists like the Borana are seven times less likely to attend school than their settled counterparts. For girls, schooling is even less likely. Although women do most of the daily chores, it is culturally ingrained that they are of less value than men.

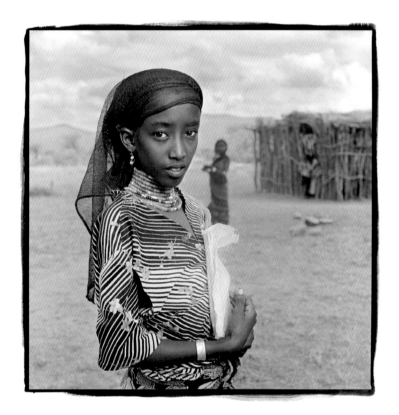

LOCO, 9

Loco's teacher said she is one of his brightest students and always
takes the initiative to step up in front of the class to answer questions. Loco
would not have had the opportunity for an education, were it not for Gilo's efforts.

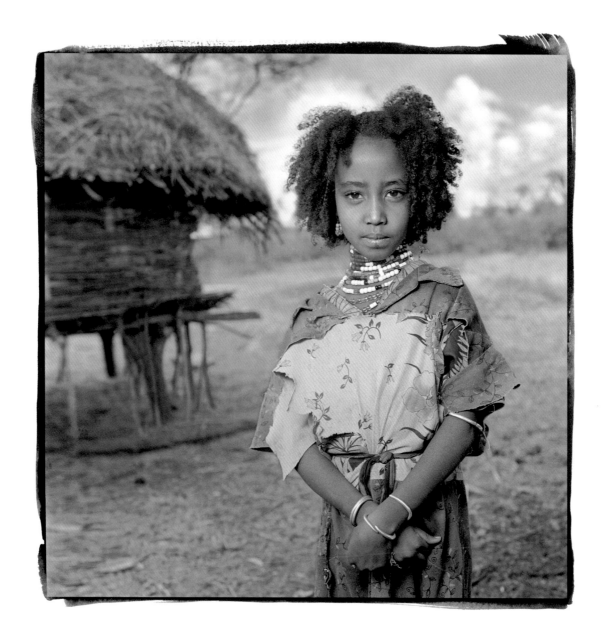

RUFO, 7

Rufo, Loco's sister, spends her day collecting water and firewood, herding goats, and
helping her mother cook. Her mother can afford education for only one of her seven children, so
every morning Rufo accompanies Loco to the school, says good-bye, and then returns home to her daily chores.

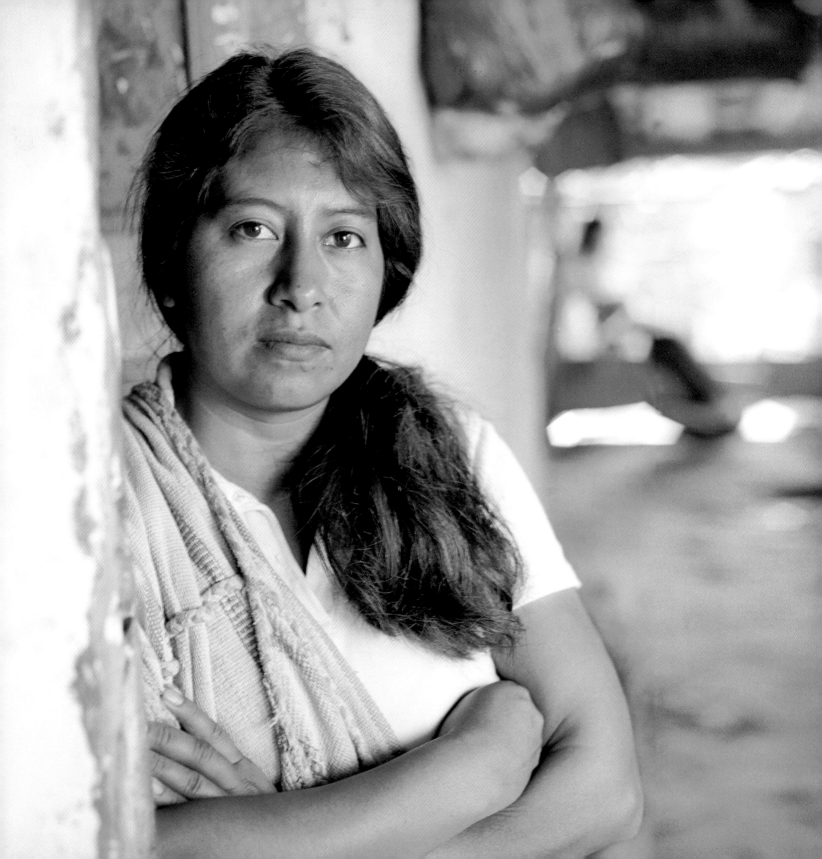

GLORIA, 24

SUIPIRA, ECUADOR

Gloria is widely respected as one of the first female leaders in her community.
At age 18, by sheer force of personality she convinced the fiercely independent members
of her community to unite and fix their age-old water problems. They had long suffered
from water-borne illnesses, an inconsistent supply, and fights over access to the village's
only spring. Seeking a remedy, Gloria generated a workable budget (thirty-seven
thousand dollars) and convinced CARE to donate the necessary materials
for a sophisticated water treatment system. She then organized more than seventy
"mingas" (community work parties) to dig miles of trenches and assemble the system.
Suipira now has the most sophisticated water system in the area—an incredible
achievement, especially for a young woman in this culture.

In southern Ecuador, mountain communities thrive or decline depending on access to potable water.
Suipira's future has been guaranteed largely due to the efforts of one tenacious young woman.

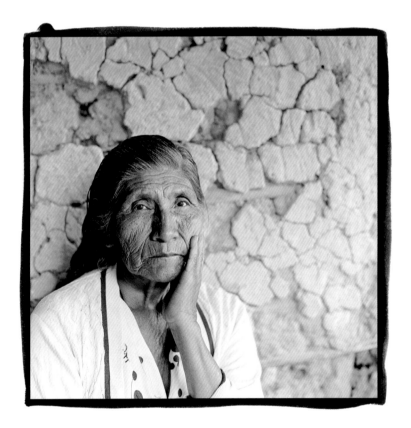

MARIA TOMASA, 67

Maria is ecstatic about the new water system that Gloria spearheaded, especially the
water meters. "In the past, everybody looked down upon me because I had the best garden," Maria
said, explaining that her neighbors were suspicious that she was using more than her fair share of water.

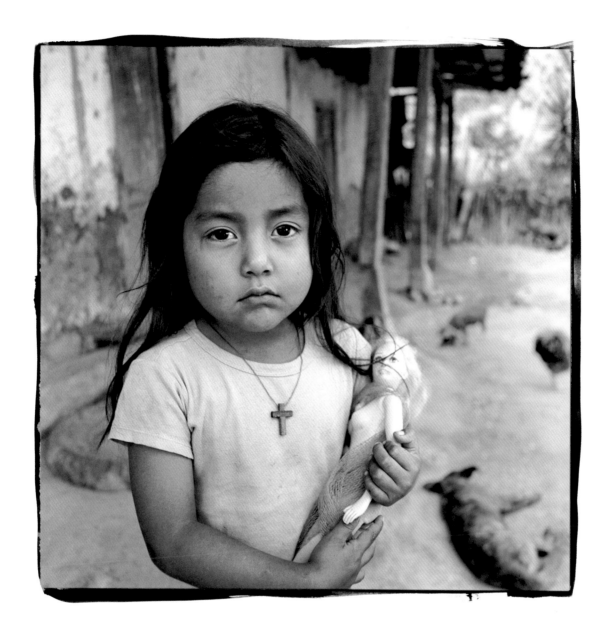

GENESIS, 4

Thanks to Gloria's work, her daughter Genesis will be safe from contaminated
water. In the past, young children often died of dysentery and other water-borne diseases.

NANA GYETUAH, 56

DEKOTO JUNCTION, GHANA

Nana, known as Madame Koko, became the first
female chief of her village. As such, she fought for the
rights of the villagers whose cocoa trees were being destroyed by
the timber industry. When loggers destroyed and refused to repair
a bridge, she mobilized her fellow villagers to create a roadblock.
Her superior, the "stool chief," complained when she exposed the
corrupt relationship he had with the timber industry. He had her
arrested, and she spent a month in jail. After CARE helped
secure her release, she returned to seek restitution for her
community's ruined farmland. Madame Koko has successfully
decreased the amount of logging in her territory, and her
strength and position as chief make her a strong role
model for the young women in her village.

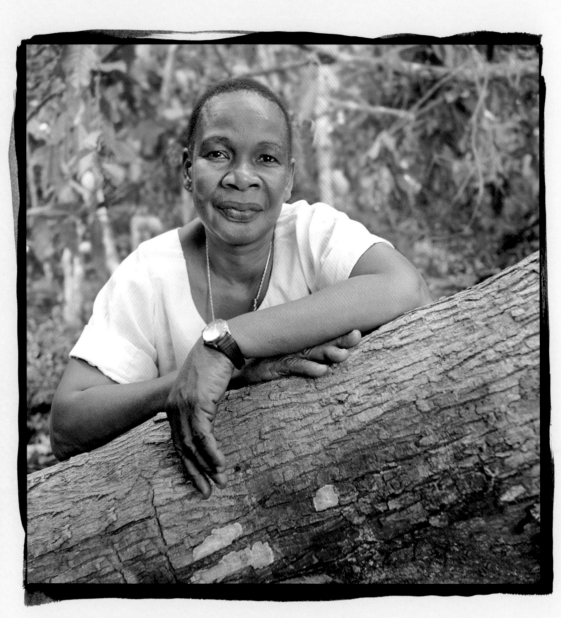

Sixty percent of Ghanaians depend on forest resources for their livelihood. As of 1990, the country had lost eighty percent of its trees to the timber industry. Historically, the government has not allowed communities to make their own land management decisions.

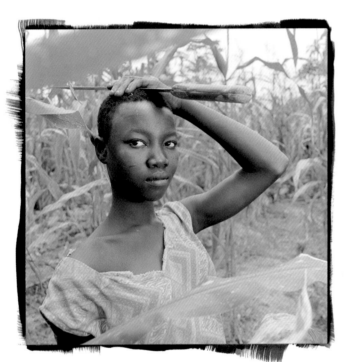 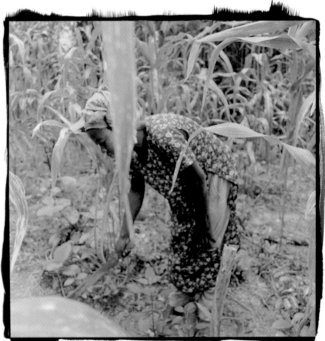

AUGUSTINA, 13

Augustina's family is typical of the villagers for whom Madame Koko has advocated for. Heavy logging damaged the fields of Augustina's family farm. Even though she works seven hours a day in the fields to help her family survive, she spends another five hours a day in school, and dreams of becoming a math teacher.

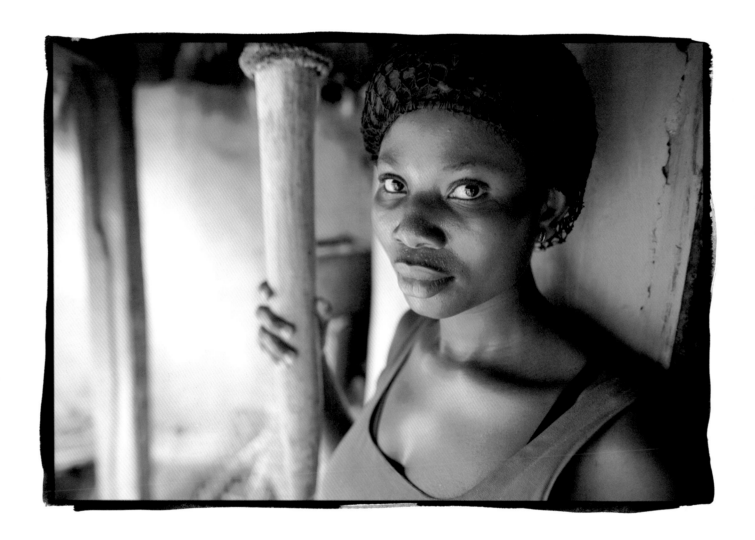

GIFTY, 22

Gifty is Madame Koko's daughter-in-law. She said the "stool chief"
had replaced the former (male) chief of Dekoto Junction with Madame Koko
because he thought it would be easier to control a woman. He got a big surprise.

BEATRICE, 8

Beatrice is one of the brightest students in her third-grade class. She said she
might want to be Dekoto Junction's chief one day. Madame Koko told me, "Even though I am
their chief, I'm just one of them. If they see me having success, they know they can have success."

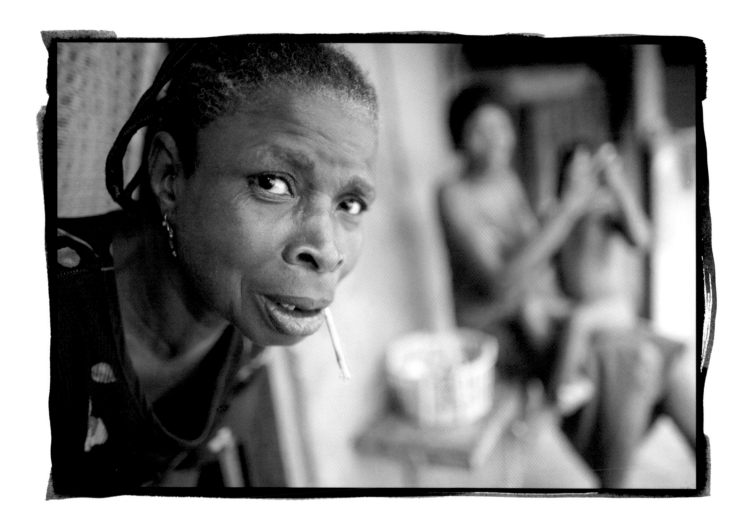

PORTIA. 65

After years of farming only cocoa and plantains, Portia has begun to
experiment with new enterprises, such as raising snails and beekeeping. Madame Koko has
inspired her community to "test drive" many new farming ventures in an effort to diversify their economy.

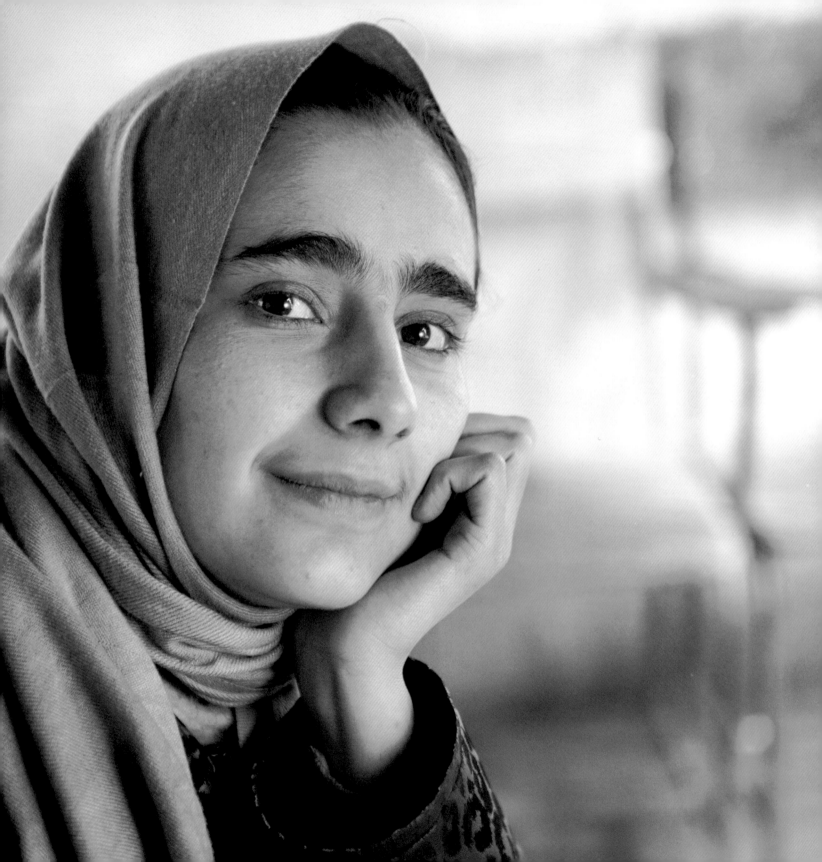

FARZANA, 21

KABUL, AFGHANISTAN

After the end of Taliban rule in 2001, Farzana emerged as one
of the first female free-lance photojournalists in Afghanistan. Her photographs
of the first elections and the plight of widows after the fall of the Taliban
have been featured in numerous international publications.
Her dream is to create a book about Afghanistan to share with the world.
"Everything I remember has something to do with war," Farzana said. "I feel I am
at peace now, but not completely; peace in Afghanistan doesn't mean 'not war,'
it means people having freedom. Women are not completely free."
When we spoke, she had recently completed a story on
the Women's Garden, an area formed for
women to gather and talk freely.

Photography was prohibited under the Taliban. In 2002, AINA Photo was established to help rebuild the communication infrastructure in Afghanistan by offering courses in photojournalism to young students like Farzana.

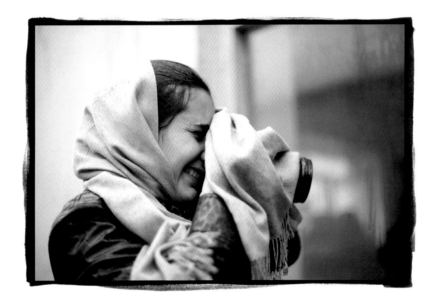

FARZANA

While searching local newspapers for job opportunities, Farzana
discovered the organization AINA Photo and enrolled in their classes. Within
a year, she had not only mastered her photographic craft, but had learned English as well.

Farzana took this photo while assisting me at a girls' school; it was her first exposure to a professional digital camera. I watched as she became completely absorbed while working with her subject. Standing on a wobbly chair in the pouring rain, she played with selective focus until she got the result she wanted.

HASINA, 35

MIPUR VILLAGE, BANGLADESH

For years, Hasina struggled to provide her family's daily meals. Living in a
slum on the outskirts of the capital, Hasina and her family survived on a diet of bread
and rice; some days, they ate nothing at all. Hasina's life began to improve when she received
her first microcredit loan and business counseling from CARE. With just forty-five dollars,
she started a small poultry farm that grew into a highly successful business. Soon her
family had saved enough money to build their own home as well as an
additional ten homes that they rent to other families.

Despite her illiteracy, Hasina was able to build upon her business success
and become a respected community leader. As the head of her village's governing
council, she helped establish a health clinic and created a door-to-door counseling
service to combat domestic violence. She also led fundraising efforts to install a
community well. Her dream is for everyone in the village to have a
good home, an honorable job, and a good education.

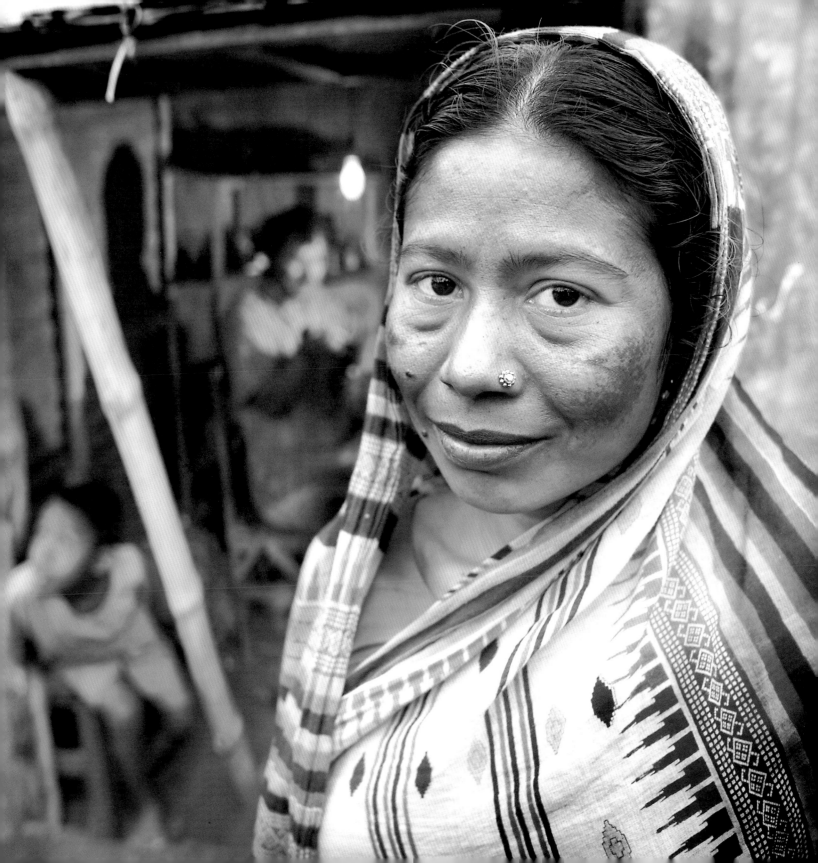

Before the installation of the community well, most children occupied their days traveling to the village's closest water source, some six miles away. The well has enabled hundreds of children to pursue an education.

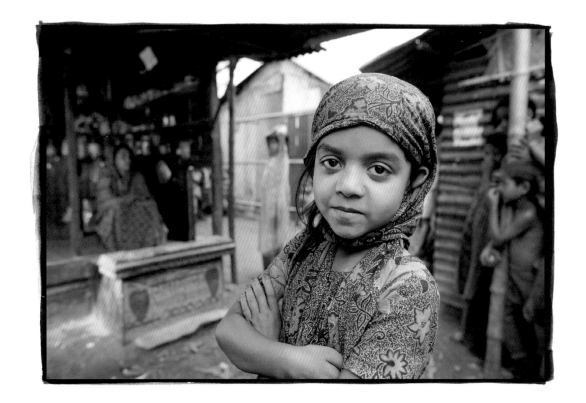

MARZINA, 7

Marzina is in first grade and loves to read. Her family
moved to Mipur because it is one of the few slums in which most
of the children go to school. They live in one of Hasina's rental homes.

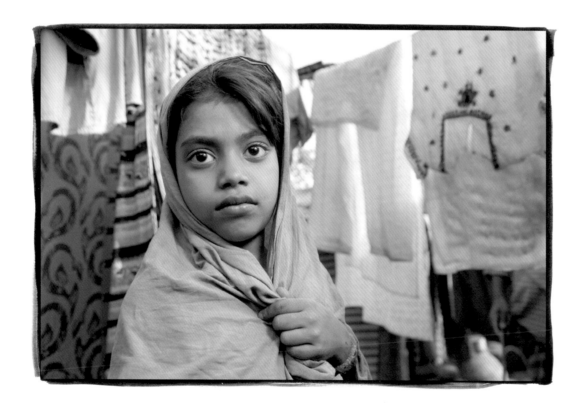

LAIJU. 8

Even seemingly small improvements in community infrastructure, like Hasina's well project,
can make an immense difference in people's lives. Previously, Laiju spent her days fetching water for her
family. Since the construction of the well, she has been able to attend school, where her favorite subject is Bengali.

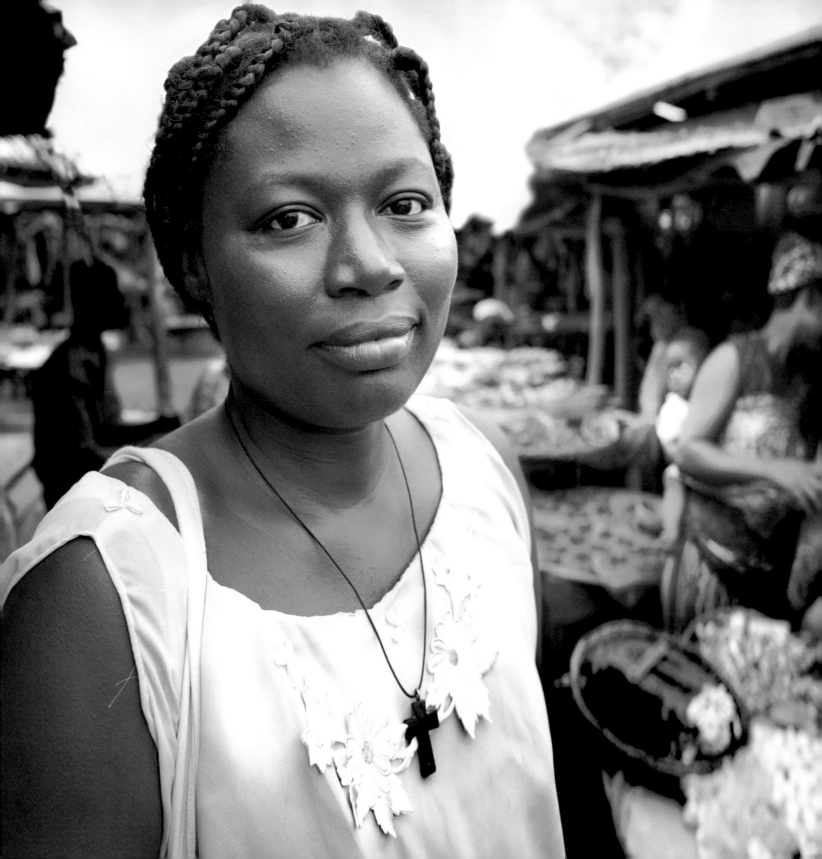

ROSALINE, 35

DOGBO, BENIN

Rosaline fights against two threats looming over impoverished girls in
Benin: child trafficking and forced marriage. Most young girls are voluntarily handed
over by their desperately poor parents, who have been led to believe they are providing a
better future for their child. To bring awareness to this issue, Rosaline started a Social
Promotion Center in conjunction with CARE. As a result of the program, laws have
been passed to bring traffickers to justice, the frequency of forced marriage
has fallen significantly, and hundreds of parents have been
educated about the risks of child trafficking.

Rosaline often brings child victims into her home until she
can find long-term solutions for their care. She hopes to create a center to
house and provide job training for trafficked children, so that they can
eventually achieve economic independence.

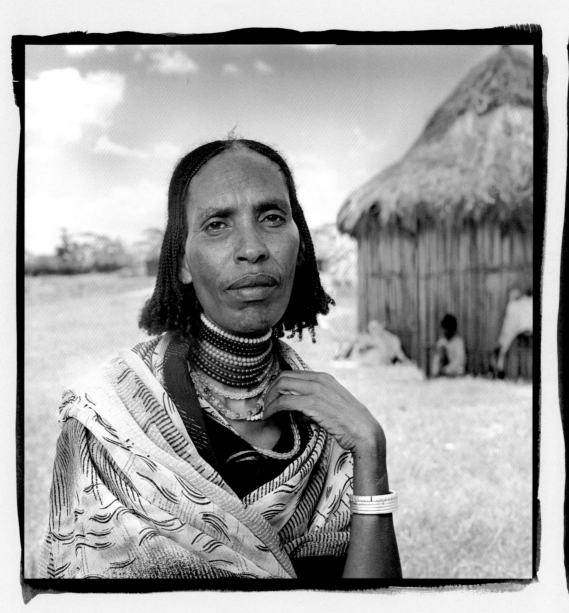

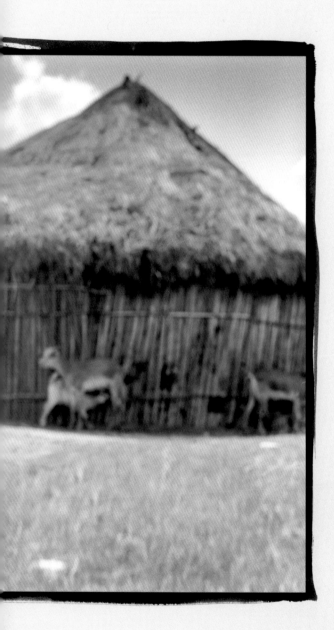

GODANA, 48

YABELO, ETHIOPIA

Historically, key community decisions for the
Boran tribe have been made by men at the Durni Eldelo,
an important meeting held every eight years. Godana broke
tradition by attending this meeting and speaking about issues
relevant to women. She courageously brought up topics that had
been neglected, such as reproductive health, family planning,
and HIV/AIDS prevention. Today, Godana works for CARE
as a community educator striving to dispel popular myths,
such as "babies come *only* by God's will." In addition to
her extensive community work, she also runs a small
business, farms, and cooks for her nine children.

In the Boran culture, sex is strictly forbidden before marriage; however, it is widely acceptable for both men and women to have many partners after they are married. Popular misconceptions regarding HIV/AIDS and family planning have only recently been addressed.

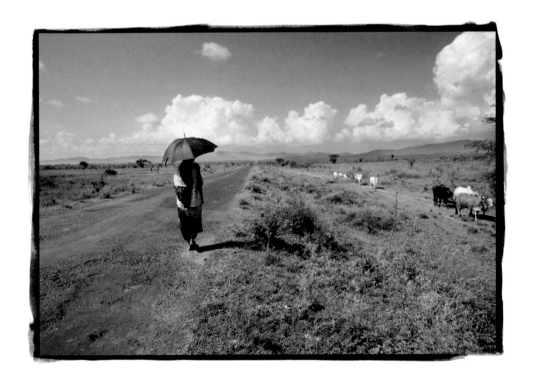

GODANA

Despite being recently diagnosed with tuberculosis, Godana
tirelessly visits homes in five neighboring villages to educate women about
family planning. She spends an hour at each house and walks for up to twelve miles between villages.

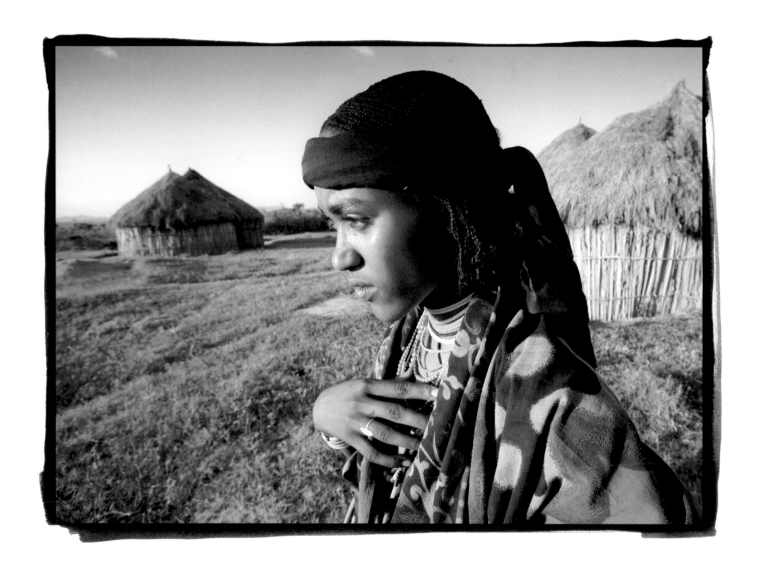

DADI, 16

Godana dedicates almost twenty percent of her salary to keep her daughter
Dadi in school. Typically, young girls are married to older men and do not finish their education.
When the men die, it is against tradition for women to remarry. This results in many single-parent households.

ROSA, 27

IXTAHUACAN, GUATEMALA

After Rosa was brutally raped by a group of four men, she broke
a tradition of silence and became one of the first women in her village to press charges
against her attackers. Although she hesitated initially—the attackers threatened to
take her life if she spoke out against them—Rosa embraced the encouragement of her friend,
Maria, a CARE outreach worker, and took the perpetrators to court. One of her assailants
was the mayor's brother, and the mayor and the judge repeatedly pressured her to drop the case.
She persisted and won. Her assailants were sentenced to a month in prison and fined
1,300 dollars. Although Rosa won her case, many in the village questioned the
court's sentence—the men had raped, but they had
not killed, so why should they go to jail?

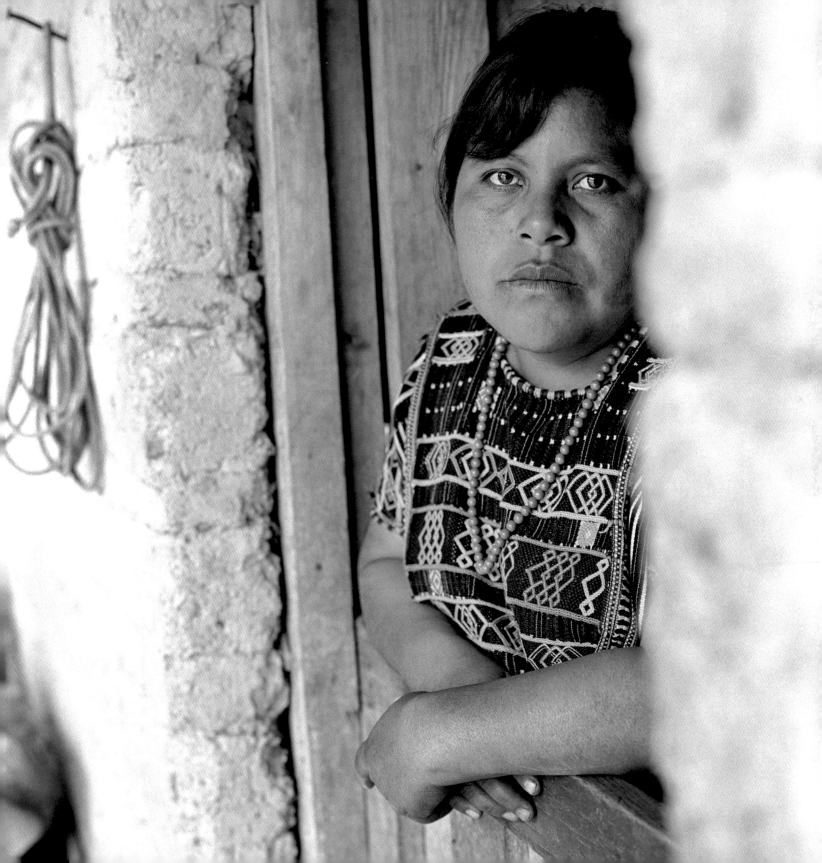

In Ixtahuacan, the indigenous Mayan people are marginalized by the "ladinos," and within the Mayan community,
women and girls are discriminated against with regard to education and social justice. Mayan women are
the marginalized of the marginalized, and violence against them is widespread.

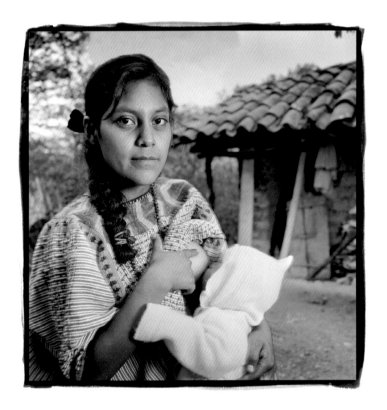

MARIA, 22

At age 17, Maria began training with CARE on women's rights,
racism, mediation, and self-esteem. Three years later, she went to work for CARE,
conducting workshops for women in Ixtahuacan. Rosa was one of her most courageous students.

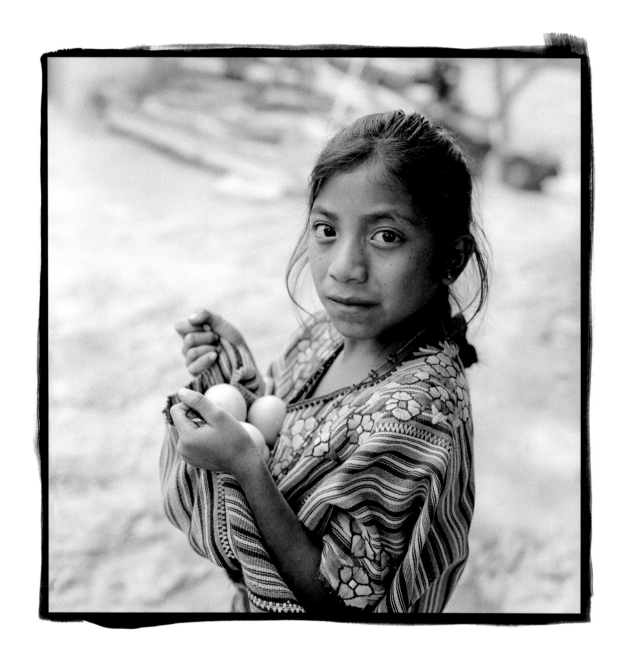

ESPERANSA, 9

Esperansa is the first girl in her family to attend school. Her mother, Catarina, although
illiterate, leads a group of eighty indigenous women in their struggle to gain gender equality and
end racial discrimination in Ixtahuacan. Like Rosa, they have chosen to confront the injustices they face.

HOMIARA, 49

KABUL, AFGHANISTAN

After her husband was killed during the mujahideen fighting,
Homiara fled to Pakistan to secure an education for her daughters. After the fall of
the Taliban in 2001, she returned to Kabul to find her home and the surrounding
neighborhood demolished. Undeterred, Homiara joined a CARE-sponsored job training
program for widows. Within two years, she was able to fund the rebuilding of her home and
her daughters' school tuition. I was impressed by her fervent dedication to their education.
When I asked what she hoped for the future, she said she wants to see her children
educated and living a good life: "I am very hopeful. Before, women had to hide their
faces and could not work. Now, I feel very positive about the future."
Her 15-year-old daughter Rona is studying to become a doctor.

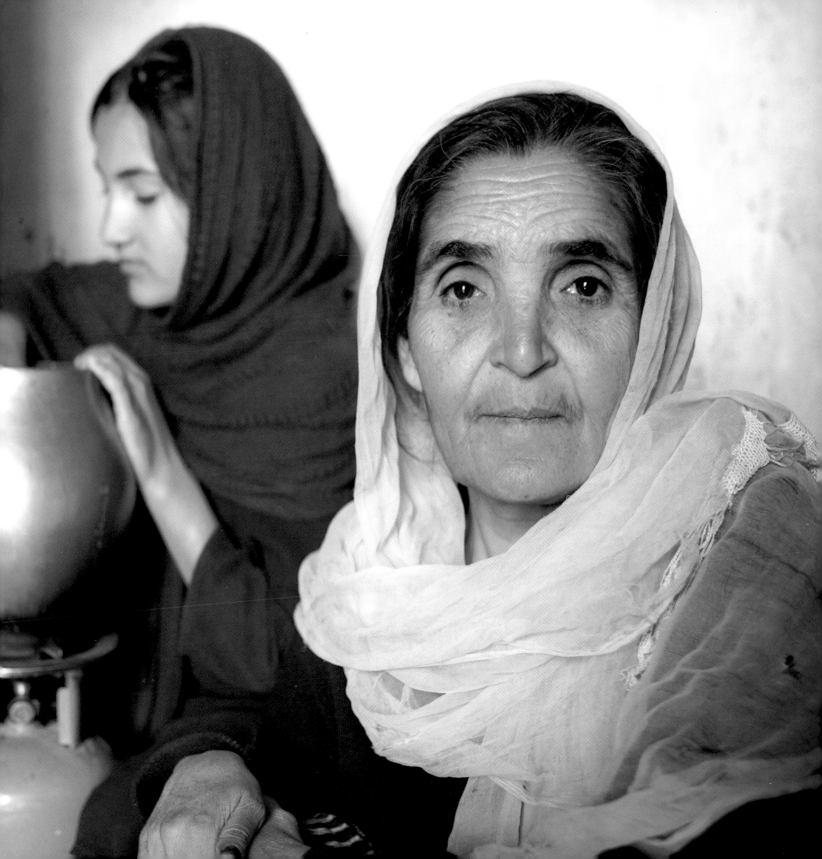

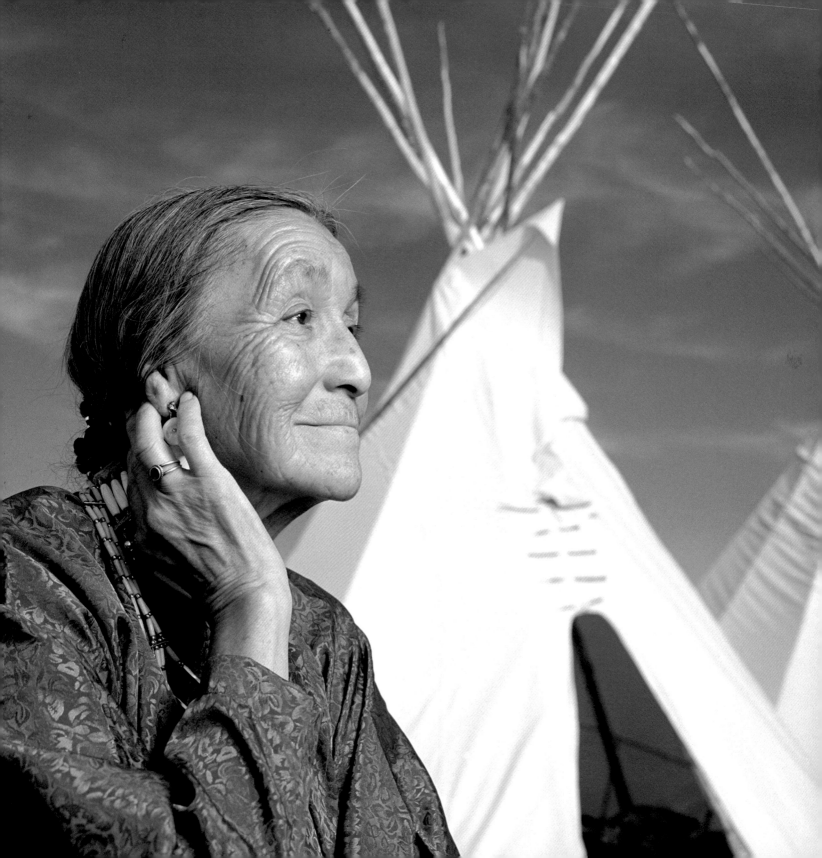

LUCILLE WINDY-BOY, 71

ROCKY BOY, MONTANA

Lucille was 66 when she and her husband enrolled in a local college.
For years, Lucille had been well known around Rocky Boy for her high-quality tepees,
and her husband was widely respected as a spiritual leader. She said college gave her a chance
to learn new ways, and she wanted to set an example for the young people in their community.
When I met her at the Rocky Boy powwow, she was surrounded by some of her forty-two
grandchildren and thirty-two great-grandchildren. Her 15-year-old great-
granddaughter very proudly noted that Lucille and her husband
had recently earned their bachelor degrees.

STEPHANIE, 16

Stephanie excels in high school and has been dancing in powwows since she could walk. As an outstanding
student and prize-winning fancy dancer, she, like Lucille, is a role model for her community. In the past, Native
American students have had some of the highest high-school dropout rates of any ethnic group in the United States.

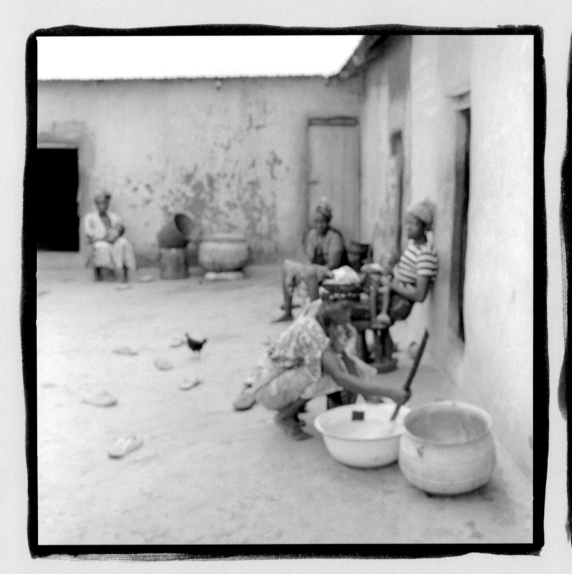

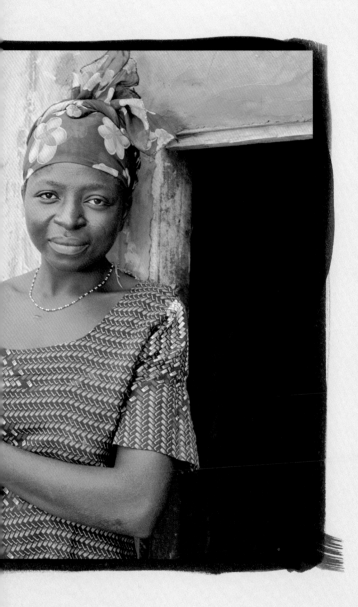

ADJOA, 28

BOWKU VILLAGE, GHANA

Adjoa is the youngest of four wives and spends
most of her time in the field tending the grain and corn crops.
The other wives share the household chores, but Adjoa prefers
working communally on the farm with the other women
in the village, instead of spending time alone
in the kitchen over a hot smoky fire.

Last year, CARE helped Adjoa form a women's
savings and credit association. Having access to loans
allowed the women to afford preventative health care items for
their children, such as mosquito nets and medicine, which their
husbands had been hesitant to purchase. During their group
meetings, the women also discussed family planning and
women's rights. They discovered that they had a more powerful
voice collectively than as individuals. Gradually, they became
less shy about speaking out at community meetings, and now
the women contribute substantially to the previously
all-male village meetings. As word of the success
of the Bowku women's group has spread, the women
are being asked to help form women's associations
in neighboring villages as well.

Historically, the women in Bowku Village did not have regular group meetings. After CARE helped the women define an operational model
for savings and credit associations and to elect leaders, their membership grew rapidly, prompting the formation of additional groups.

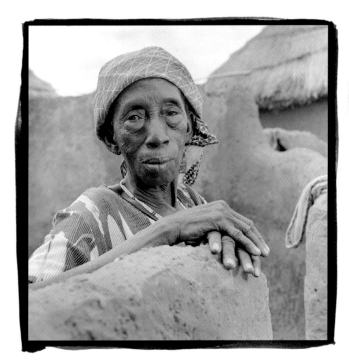 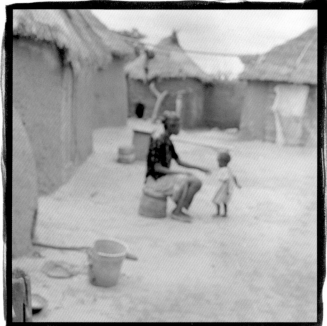

AZUMAH, 80

Azumah spoke with great pride about the progress that women have achieved
in Bowku Village. Azumah's daughter is now the treasurer of Adjoa's savings and credit
group. "Everything has changed in the last few years. Now women have a say in our village," she said.

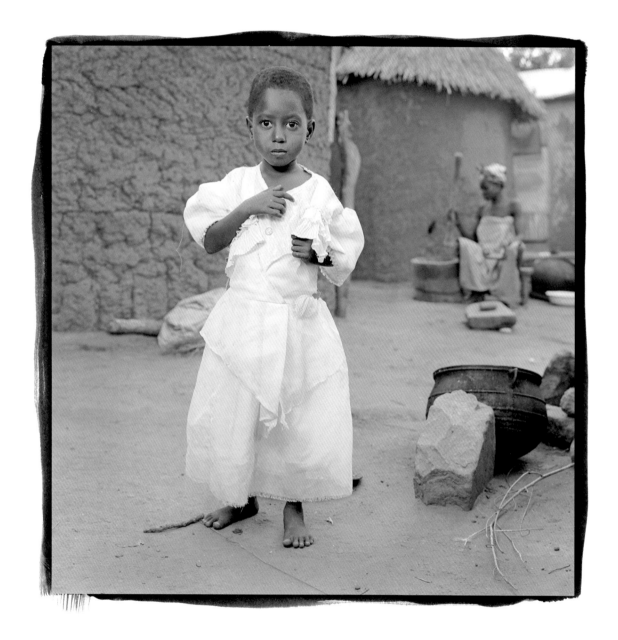

BASHIDU, 6

CARE began a program teaching gender equality in Bowku Village ten years ago. Because
of the program's emphasis on female education and delayed marriage, there is a good chance
that young girls like Bashidu will be allowed to continue their education through secondary school.

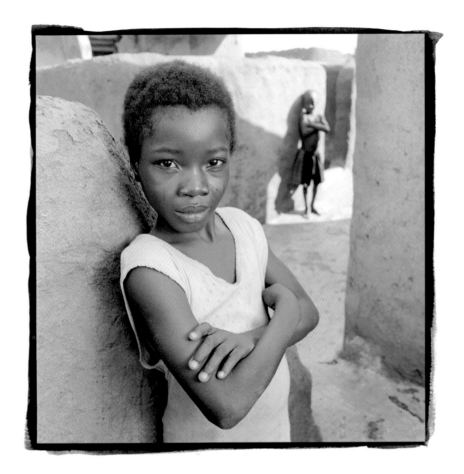

LATIFA, 9

Latifa is responsible for hauling water, cooking, and tending the
corn-field. Because of the demanding schedule of girls, school dropout rates are
high, with many girls getting married as early as age 13. However, due to Adjoa's
efforts in emphasizing the importance of an education, Latifa attends school six hours a day.

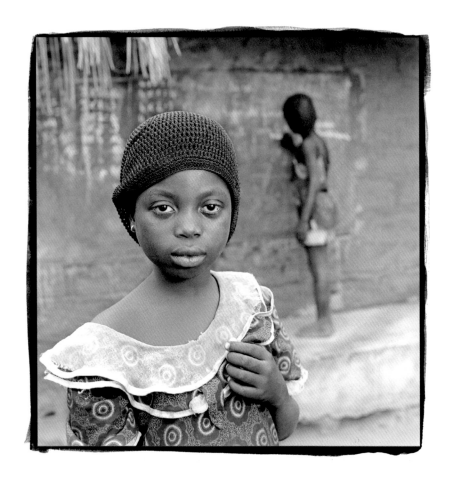

WOULI, 7

Although Wouli has to spend four hours a day fetching water and firewood, she still does her
homework religiously. Working with her best friend, Atinyo, she spends two hours after school practicing
her language and math assignments on a chalkboard her father attached to the side of their house.

There is not the woman born who desires to eat the bread of

dependence, no matter whether it be from the hand of father, husband,

or brother; for any one who does so eat her bread places herself in the

power of the person from whom she takes it.

—SUSAN B. ANTHONY

SHEILA C. JOHNSON

CAN YOU IMAGINE changing your life with twenty dollars? In rural villages and urban slums around the world, even minimal capital in the hands of a poor woman with a vision can alter not just one life, but dozens. Women have the power to create, lead, and bring about change. But for women to realize their destinies and be in charge of their lives, they must gain economic empowerment. When women no longer struggle each day to keep hunger and disease at bay, they are better able to care for themselves, nurture their families, and contribute to the betterment of their communities. Take for example the women in this book. By standards in most developed countries, these women and their families are still poor; but their spirits have been enriched by the experience of seizing an opportunity and making the most of it. They are able to see themselves—their worth, potential, and dignity—clearly, perhaps for the first time. This is why economic empowerment is about more than dollars, rupees, or pesos; it's about a woman realizing her own true value.

Sheila C. Johnson is an entrepreneur, educator, and philanthropist.

AMENA, 35

GAZIPUR, BANGLADESH

After Amena's husband left her, she worked for several
years as a servant to support her two children. A friend told
her about CARE's Rural Maintenance Program, a four-year program that
employs widowed and disadvantaged women for one dollar and twenty-five
cents a day. Participants are guaranteed a job, so long as they save twenty
percent of their income and participate in extensive health, literacy, human
rights, and business management classes. After completing the program, she
used the 180 dollars she had saved to purchase a cow. Three months later,
she sold it for 240 dollars, and eventually built her herd to six cows. Today,
she owns a home, a bull, and six cows, and farms twenty-five acres of rice.
In the past, women like Amena have rarely had the opportunity
to rise from servant status to own their homes.

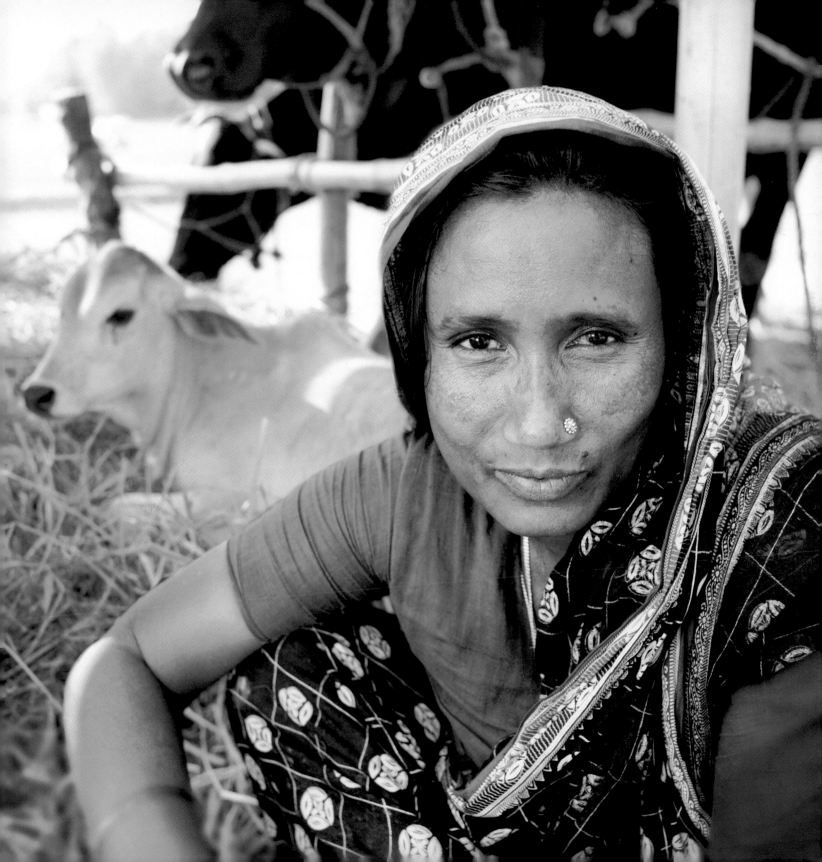

Every year, seven thousand women graduate from the Rural Maintenance Program and start their own businesses.
The program targets the most disadvantaged women in the country, most of whom are widowed, divorced, or abandoned.

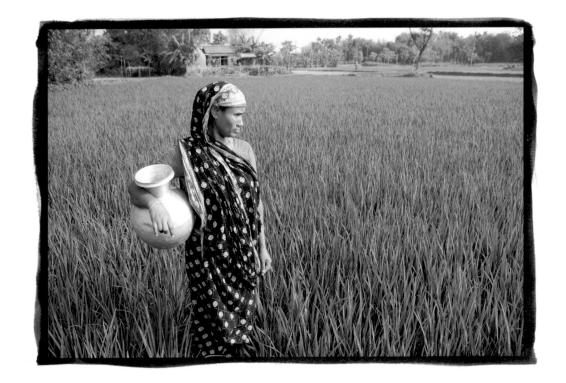

AMENA

Amena currently rents this land, which allows her to grow 2,800 kilograms of rice each year.
Her ultimate goal is to purchase the land and double her herd of cows within three years. Even though
Amena is illiterate and can only sign her name, she has become a very successful business women.

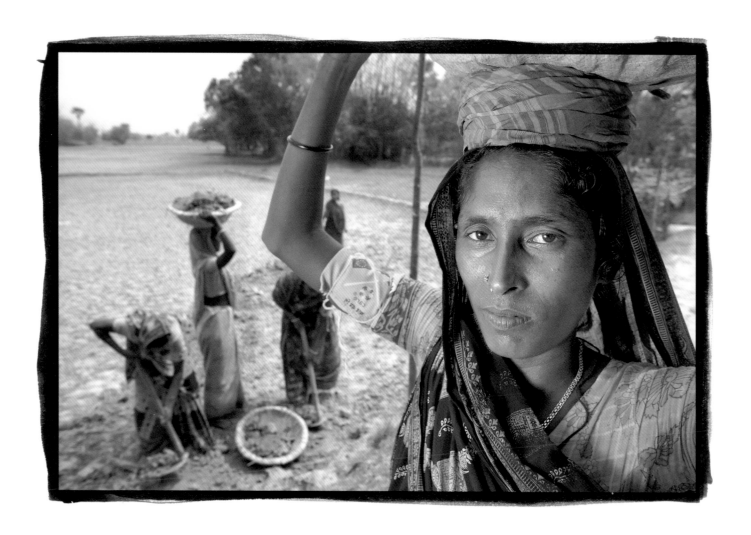

MABIA, 32

Mabia's husband died of hepatitis while she was pregnant with her son. Like Amena, who
lacked the support of her husband, Mabia qualified for the Rural Maintenance Program two years ago.
She now has enough money to send her 11-year-old son to school and is saving to start her own grocery business.

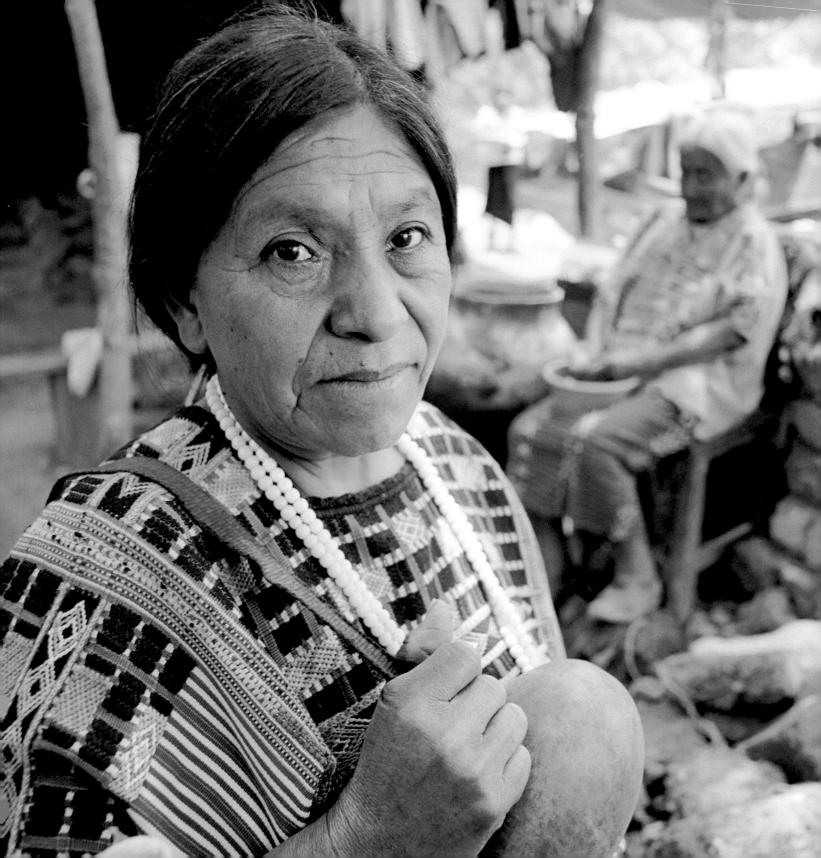

JUANA PEREZ, 50

IXTAHUACAN, GUATEMALA

Juana organized the first microcredit loan program for women in her hometown
of Ixtahuacan after participating in a similar CARE program in a neighboring village.
With her first loan of forty-five dollars, she was able to purchase fifty chickens and sold them
a few weeks later at a forty percent profit. She now purchases one thousand chickens at
a time and has earned enough to send four of her seven children to school.

Microcredits are allocated to groups of twenty to thirty women. If a person defaults
on the loan, the remaining women are held accountable. As structured, these loans have an
extremely low rate of default and are much more successful with women than men.
Today, Juana is president of her twenty-five member group and spends her time teaching
women how to earn and manage money. She hopes to expand the program
to help more women in her village and in the surrounding rural areas.

BKAT NAZERA, 29

KABUL, AFGHANISTAN

As a young girl, Bkat loved to sew and design clothes,
but never imagined she'd be able to own a clothing business.
After the fall of the Taliban in 2001, she collaborated with CARE on a vocational
training program for war widows and started her own sewing center,
employing the widows as seamstresses. An Afghan wife is traditionally protected within
the extended network of her husband's family, but the husband's death often leaves her
unable to earn a living or support her children. The CARE project provides training in sewing,
embroidery, and knitting for 2,200 widows in Kabul. Bkat dreams of growing
her business so she can employ more widows and eventually
open shops in other provinces and countries.

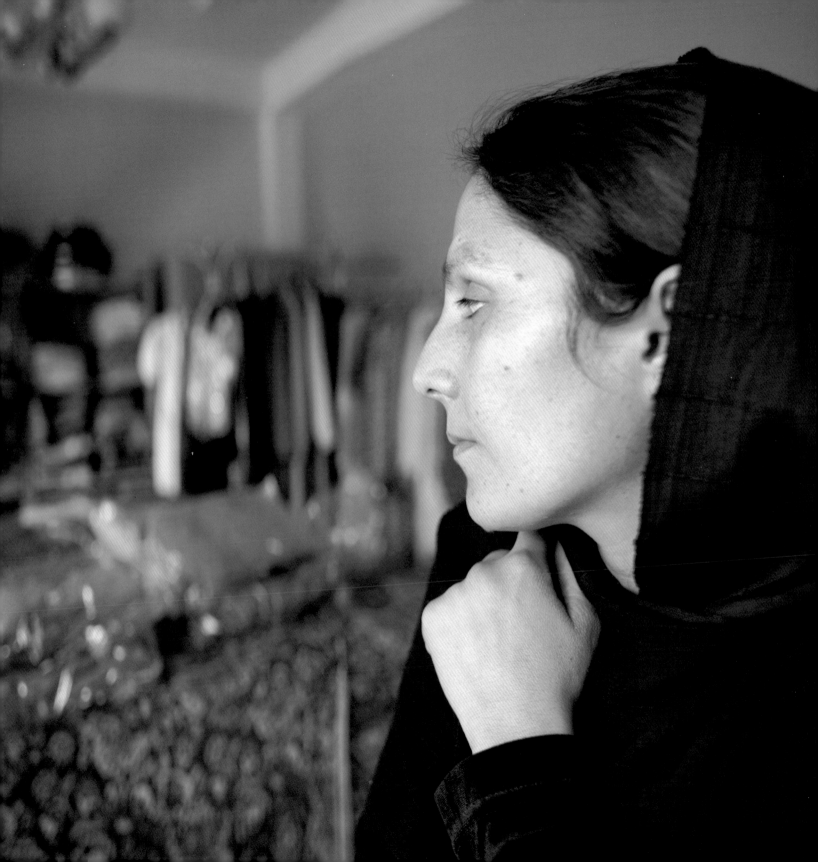

A quarter century of war has left fifty thousand war widows in Kabul alone. The vast majority of these women are illiterate, have few marketable skills, and live on just one dollar a day.

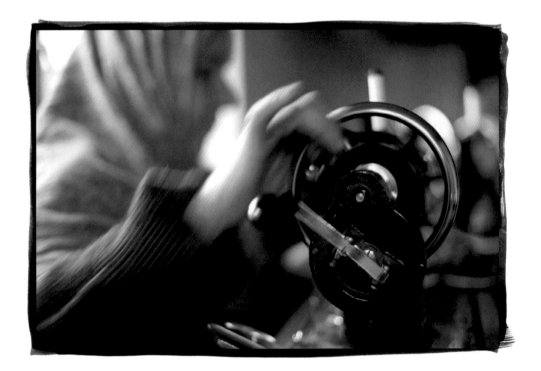

Since the shop has no electricity, the women operate sewing machines
by hand and use propane stoves to heat the irons. Bkat's sewing center provides
a social outlet for these women, as well as being a crucial lifeline to escape the cycle of poverty.

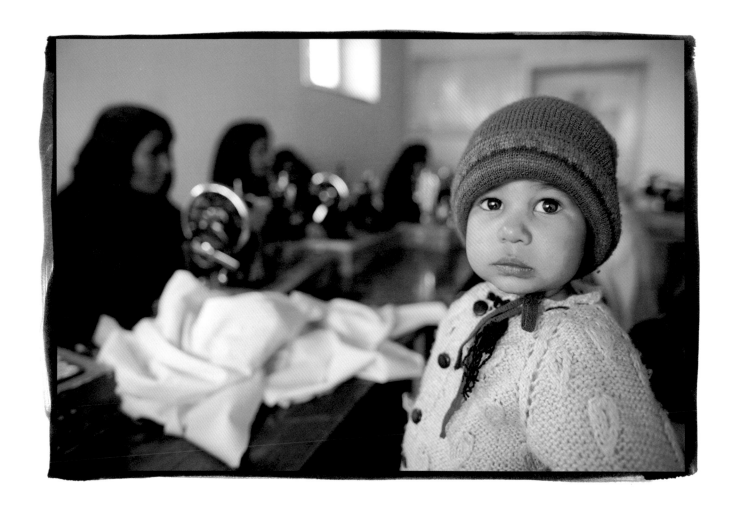

AHMAD, 2

Ninety percent of the war widows in Kabul have children. Bkat's business
has helped such women provide for themselves and maintain their families. Ahmad
spends his days at the sewing center, playing with the fabrics and helping his mother when she irons.

TEKE FOLIWA, 42

HAVE, GHANA

Recently, Teke was crowned "Queen Mother" of
Have. Her first act was to form sixteen women's groups for
microcredit loans, agriculture production, and education reform.
Initially, there was concern within the community that she was
gaining power too quickly. "Women are expected to be submissive
to the men," she said, "Traditionally, a queen is just a figurehead;
she dresses up for festivals and serves as a role model to teach
women to be beautiful, quiet, and demure. After my training with
CARE, I realized that I could serve as a different kind of
inspiration for the women here."

Eventually, the men became impressed with the
progress being made by the women and asked for their own
groups. "This has moved us forward toward becoming a true
community," Teke said. "It's not just the men and the
women, but all of us moving forward together in a
much more uniform way."

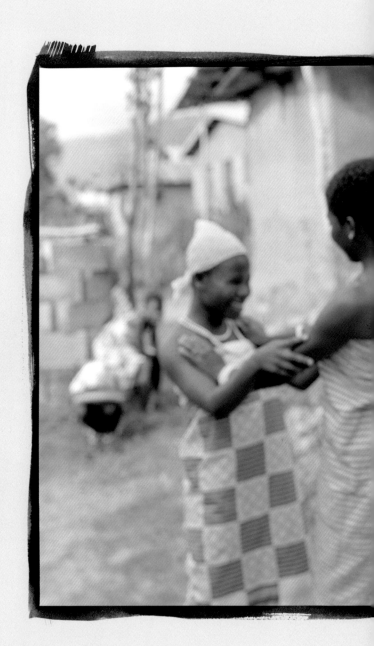

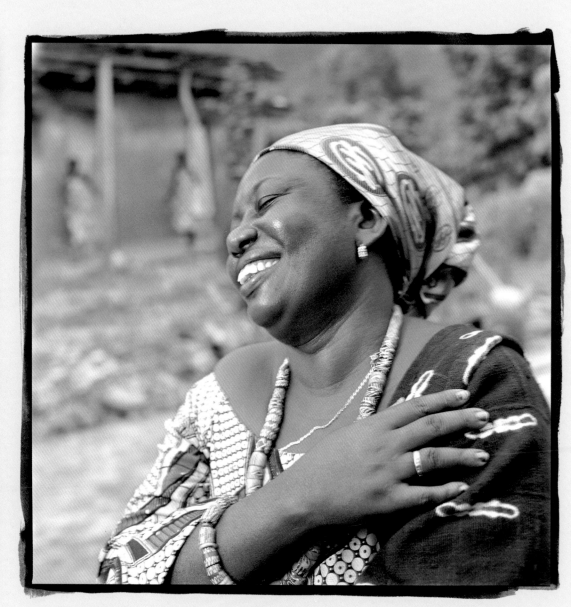

In Have, girls typically marry before finishing school. It is common for husbands to abandon their families,
leaving the women without any vocational skills or means of support.

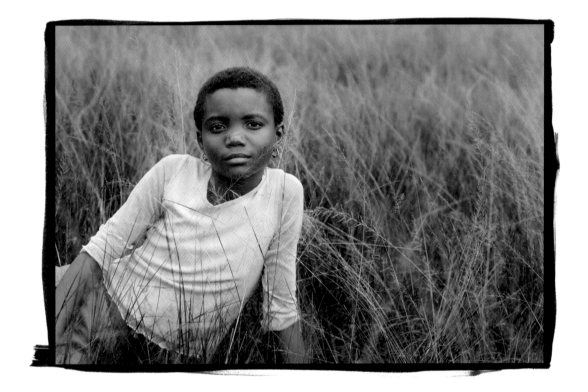

NAIDA, 9

Initially, Naida's mother was unwilling to send her to school.
She changed her mind after Teke brought in doctors, lawyers, and professors as role
models to show the value of an education. Today, Naida is excelling in her classes.

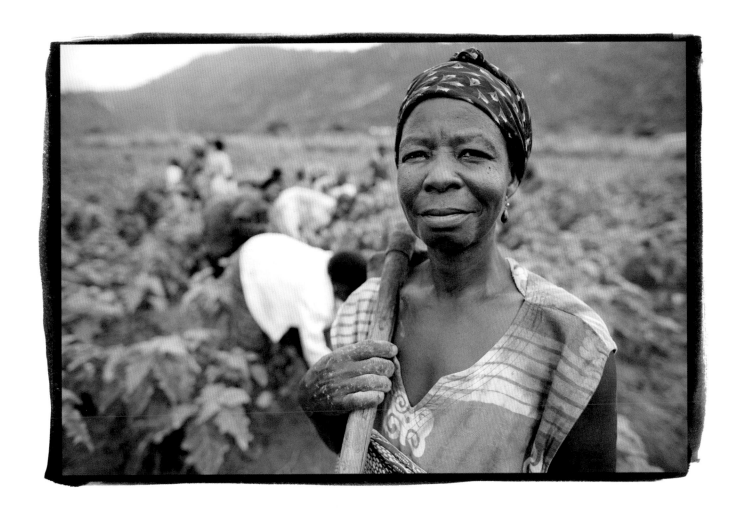

VIDA, 58

Vida used to tend to her okra and pepper garden alone. Today, she finds it is not only more profitable
but much more fun to work in a women's group. Because of Teke's leadership, over 250 women in Have
meet each month to discuss the issues and solutions they encounter while trying to feed and educate their children.

TRANSITO, 91

CAYAMBE, ECUADOR

Transito, a legendary human rights figure, is often referred to as the
"Rosa Parks of Ecuador." After the Spanish conquest, many indigenous people were
stripped of their rights and forced to serve as indentured servants in the hacienda system. In 1926,
at the age of 17, Transito spoke out against a hacienda owner who had been molesting her.
She was sent to jail for five months for protesting her abuse. Upon her release, she became a legend
for speaking out about the plight of indigenous Ecuadorians. Later, she was instrumental in
organizing a strike by indigenous farmers, which catalyzed a newfound respect for
indigenous peoples in Ecuadorian politics and in society at large.

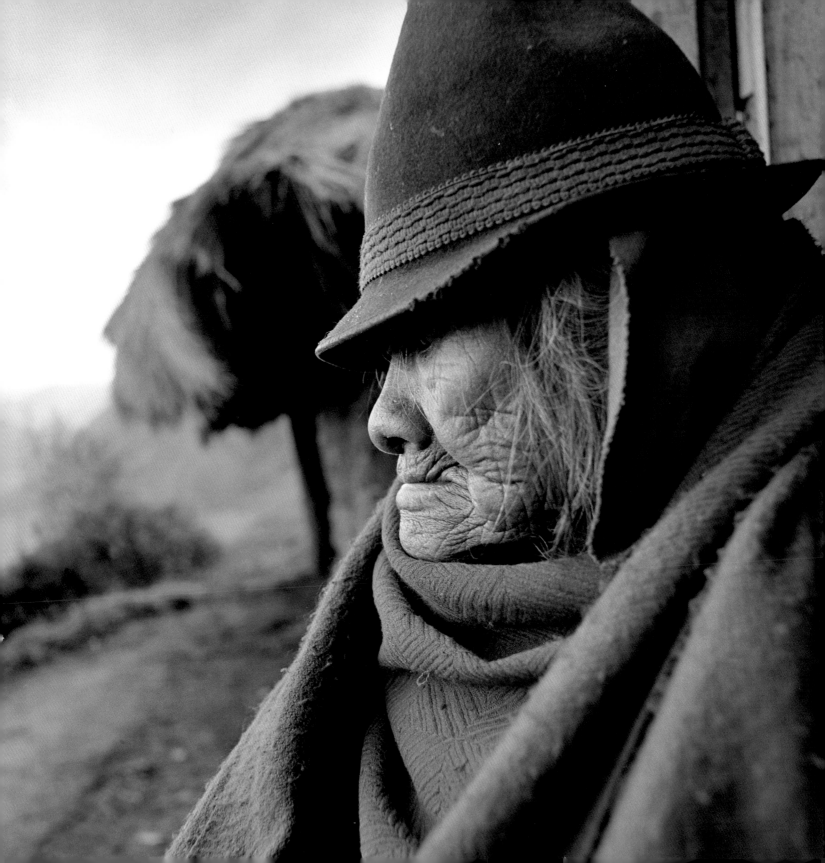

EPILOGUE

WOMEN EMPOWERED, worlds emerging. These are exciting, hopeful times.

I REALIZE THAT STATEMENT may surprise some. There are so many issues and events that could cause one to despair, or to retreat to a safe cynicism. Yet I draw strength and hope from the examples set by the women of this book. They have faced challenges that would bow the strongest among us. They have known want and grief, and still they rise each day, hopeful that it will be better than the last. Hopeful that they can *make* it better than the last.

SO, LIKE THESE WOMEN, I am optimistic. And like these women, I am not naïve. I know that real progress only comes when everyone does his or her part. We fortunate residents of wealthy nations must do what is in our power to shine a light into the darkest corners of places still emerging from the shadows of poverty and injustice. We must use our voices to persuade leaders everywhere to make wise decisions that reflect our innate love of peace and liberty. We must use our resources to offer a hand to women like those you have met on these pages—knowing they will turn and offer their hand to others. We must use our time to educate others about what is happening, and what is possible.

BY OPENING THIS BOOK, you have made a good start toward such goals. Phil Borges has produced a compelling document—proof that women empowered are creating real, lasting change in poor communities. For anyone interested in living in a better, safer, more just world, this is good news, and I encourage you to share it.

YOU MIGHT ALSO SHARE what you've learned about CARE, the organization that works with many of the women featured here. CARE is active in seventy countries, empowering women in the fight against poverty. Together with poor communities, we are making great strides, and we can do even more with additional support. Please join CARE in the most important cause of our time: ending global poverty.

HELENE D. GAYLE
PRESIDENT AND CEO, CARE USA

ACKNOWLEDGMENTS

Dedicated to Nona

I WOULD LIKE TO THANK everyone who contributed their time and talent to make this book possible: during the project's inception, Cristina Mittermeier, Bobi Downey, Kathryn Harper, and Fred Housel for their encouragement and inspiration; Chris Hlavaty and Craig Orback for their design and content suggestions, as well as file preparation; Cheryl Crow for her patience in deciphering notes and help in writing the captions; Karen Schober for her wonderful design; Gretchen Lyons, Lynn Scrabis, and Hilary Ney for their patience in editing; Valenda Campbell and Jason Sangster for their logistical support; Rizzoli's publisher Charles Miers for believing in the project, and Sandy Gilbert Freidus for helping manage the book's publication. For their support of the project, and their words in support of women everywhere, my gratitude also goes to former U.S. Secretary of State Madeleine K. Albright; author Isabel Allende; CARE USA President and CEO Helene D. Gayle; President, American Medical Women's Association, Susan L. Ivey; Black Entertainment Television co-founder Sheila C. Johnson; Nobel Peace Prize Winner, 2004, Wangari Maathai; and CARE Ambassador and author Christy Turlington Burns.

I WOULD ALSO LIKE to recognize all the CARE field staff in Guatemala, Ecuador, Afghanistan, Bangladesh, Ethiopia, Ghana, Togo, and Benin, not only for their assistance with this project, but also for their work in addressing global poverty and all its attendant ills. Also, my deepest respect and appreciation goes to the women highlighted in this book, who freely offered their time and their stories.

FINALLY, MY LOVE TO Stacie, Barbara, and Linda, and especially to my wife and partner Julee Geier, who is a never-ending source of inspiration, support, and feedback in all we attempt to do.

First published in the United States of America in 2007
by Rizzoli International Publications, Inc.
300 Park Avenue South
New York, New York 10010
www.rizzoliusa.com

Sources
Page 12 (top to bottom)
from United Nations, as cited in Oxfam; from The World Bank, *United Nations Chronicle* (online ed.), Stephen Nolan, "Working Together;" from The Women Lawyer's Association, *The Political Participation of Women in Ethiopia: Challenges and Prospects*, prepared by Tigist Zeleke, April 2005; from "UNHCR, United Nations Refugee Agency," *Refugees Magazine*, April 2002; from Save the Children, "State of the World's Mothers 2005: The Power and Promise of Girls' Education," © Save the Children, May 2005.

Page 13 (top to bottom)
from United Nations; from L. Heise, M. Ellsberg, and M. Gottemoeller, "Ending Violence Against Women," Population Reports, series L, no. 11, 1999. Population Information Program, Johns Hopkins School of Public Health, Baltimore, Maryland; from Child Rights Information Network, "Changing a Harmful Social Convention: Female Genital Mutilation/Cutting," UNICEF Innocenti Research Center, *Innocenti Digest*, © 2005 United Nations Children's Fund; from Population Council Report, The United Nations International Research and Training Institute for the Advancement of Women.

2007 2008 2009 2010 / 10 9 8 7 6 5 4 3 2 1

Printed in the United States of America

ISBN 10: 0-8478-2927-8
ISBN 13: 978-0-8478-2927-9

Library of Congress Cataloging Control Number: 2006934937

CARE is a leading humanitarian organization working to empower women in the fight against global poverty.

care®

Project Editor: Sandra Gilbert Freidus
Designer: Karen Schober Book Design